Cleveland Sketchbook

Indigo Custom Publishing

Publisher	Henry S. Beers
Associate Publisher	Richard J. Hutto
Executive Vice President	Robert G. Aldrich
Operations Manager	Gary G. Pulliam
Editor-in-Chief	Joni Woolf
Art Director/Designer	Julianne Gleaton
Designer	Daniel Emerson
Director of Marketing and Public Relations	Mary D. Robinson

Printed in India

Library of Congress Control Number: 2006922863

ISBN: 0976287599
ISBN (13 Digit): 9780976287599

Indigo custom books are available at quantity discounts
with bulk purchase for educational, business, or sales promotional use.
For information, please write to:
Indigo Custom Publishing, 435 Second Street, SunTrust Bank Building, Suite 320, Macon, GA 31201, or call 866-311-9578.
www.indigopublishing.us

Cleveland Sketchbook

Text and captions by Carol Poh Miller
Art by students of the Cleveland Institute of Art

Cleveland Artists

Lindsey Alberding	Dana Hardy	Cecelia Phillips
Nina Barcellona	Drew Hood	Peter Reichardt
Albert Beltz	Chris Jungjohann	Mary Savage
Christi Birchfield	Paul Koneazny	Salvatore Schiciano
Wesley Burt	Sarah Laing	Mandy Stehouwer
Ben Dewey	Rachel Nottingham	Rachel Tag
Abby Feldman	Lindsay Parker	Andrew Zimbelman

Business Profile Writers

Brokaw Agency

Martha Elrod

Rebecca Neely

Lori Novickus

Russell Roberts

Linda Sandahl

Joni Woolf

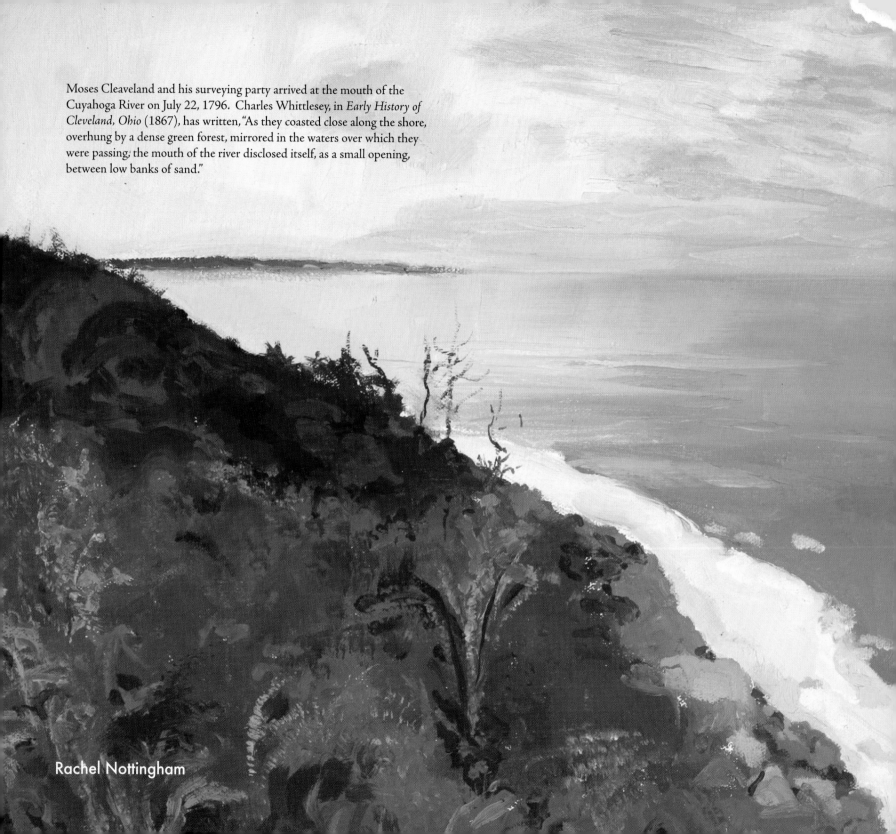

Moses Cleaveland and his surveying party arrived at the mouth of the Cuyahoga River on July 22, 1796. Charles Whittlesey, in *Early History of Cleveland, Ohio* (1867), has written, "As they coasted close along the shore, overhung by a dense green forest, mirrored in the waters over which they were passing, the mouth of the river disclosed itself, as a small opening, between low banks of sand."

Rachel Nottingham

A New England Village

The lower Cuyahoga River snakes its way to Lake Erie, just as it did when Moses Cleaveland and his party arrived, on July 22, 1796, to survey the three million acres of the Ohio Western Reserve for the Connecticut Land Company. Persuaded that the site enjoyed "the greatest communication either by land or Water of any River," they laid out a "capital town" resembling the New England villages they knew, with a ten-acre public square on high tableland above the river, bisected by two broad thoroughfares (Ontario and Superior). Connecticut native Lorenzo Carter and his family were the first permanent settlers. Carter built a large log cabin on the east bank of the Cuyahoga and, employing itinerants in exchange for board and whisky, engaged in a vigorous trade with the Indians who then still claimed the land west of the river. Poor soil, together with mosquito-borne diseases caused by stagnant water at the river's mouth, discouraged other settlers. Visiting in 1811, John Melish observed "16 dwellings, 2 taverns, 2 stores, 1 school" and a river "stagnant, foul, & putrid smelling."

The War of 1812 boosted Cleveland's prospects. The settlement served as a storage depot and the site of a fort. Lake traffic and trade picked up as hardy settlers, principally from New England and New York State, made their way west seeking a fresh start in life. The visit of the steam-powered *Walk-in-the-Water* in 1818 heralded a new era in lake travel. Merchandise from the East—furniture and books, shoes and clothing—was increasingly to be had. In 1822, the first newspaper made its debut, along with the first free bridge linking the east and west banks of the Cuyahoga. Shortly after, federally funded harbor work cut a new, straight channel between river and lake, enhancing trade and travel and eliminating the miasmic swamps that had impeded the town's growth.

Largely through the efforts of Cleveland legislator Alfred Kelley, the state of Ohio selected Cleveland as the northern terminus of the Ohio & Erie Canal, linking Lake Erie with the Ohio River. Two thousand laborers—the majority Irishmen finished with their work on New York's Erie Canal—descended on the village and filtered into the slumbering Cuyahoga Valley. They mucked out a channel four feet deep and forty feet wide at the waterline and built locks, sluices, and aqueducts. The canal was completed to Akron in 1827 and to Portsmouth, on the Ohio River some three hundred miles distant, in 1832.

The canal ensured Cleveland's economic prosperity. The struggling village became a crossroads of waterborne transportation. Mule-drawn packets arrived, carrying farm products of the Ohio heartland, and made the return trip laden with merchandise from the East. New settlers, including Irish, Scotch, and German immigrants, began to arrive. A central business district took form on lower Superior Street, west of Public Square, while residences and churches filled the high ground to the north.

Both Cleveland and Ohio City, its smaller rival on the west side of the Cuyahoga, began to thrive. Here lived merchants, self-employed artisans, and skilled workers in small shops and industries, especially the building trades. Female heads of households operated boarding houses or worked as dressmakers or schoolteachers. Substantial business centered on shipping and exchange. In 1836, almost two thousand brigs, schooners, sloops, and steamboats called at Cleveland Harbor, giving employment to merchants, mariners, dock laborers, and ship carpenters.

In 1836, Cleveland and Ohio City each became incorporated cities. A combined directory for 1837-38 notes the presence, in Cleveland, of "four very extensive Iron Foundries and Steam Engine manufactories," three soap and candle factories, two breweries, one sash factory, two ropewalks, a stoneware pottery, two carriage factories, and two French burr millstone factories. In Ohio City, the Cuyahoga Steam Furnace Company, incorporated in 1834 for the manufacture of cast-and wrought-iron work, gave employment to "upwards of 100 workmen." That firm would build the first locomotive west of the Alleghenies in 1842, and by 1849 it would be the largest manufacturer of steam engines in Ohio.

Although there was talk of annexation, logic was forgotten when James S. Clark and others financed the construction of a wooden drawbridge across the Cuyahoga that diverted northbound traffic—and business—from Ohio City into Cleveland. Tempers flared, leading to the infamous "Bridge War" of 1837 and culminating in a skirmish in which shots were fired. Although unification was finally accomplished in 1854, the two sides of town eyed each other warily for years to come.

An Industrial City

Cleveland matured quickly. By 1840, with 6,071 people, it was the most populous city in the Western Reserve. Twenty years later, it had grown sevenfold, to 43,417, prosperity arriving with ever-larger quantities of wheat, corn, flour, dairy products, coal, and wool from the Ohio interior. Village life, though, was due to change, heralded by two signal events: the discovery, in 1844, of iron ore in the Lake Superior region of Michigan; and the arrival, in 1850, of the first railroad.

By virtue of geography, Cleveland was an ideal meeting place of iron ore arriving from the north and coal arriving from the south—the ingredients of the industrial revolution. Within a decade, leisurely canal boats were eclipsed by swift iron horses and the whistle of locomotives was as familiar as the sound of church bells. The Flats was a tangle of rail lines, roundhouses, lumberyards, oil tanks, warehouses, flour mills, forges, and foundries. "Would it not be wise to start blast furnaces in Cleveland?" the *Cleveland Leader* reasoned. Entrepreneurs Henry Chisholm, a Scottish immigrant, and John and David Jones, Welshmen, answered the challenge, organizing the Cleveland Rolling Mill Company in 1863 and investing in one of the area's first blast furnaces.

With the start of the Civil War, Cleveland, which was staunchly anti-slavery, rallied to defend the Union and sent a large number of its sons to battle. The conflict exacted a terrible toll: of the 10,000 men who served from Cuyahoga County, one-third were killed or crippled. At the same time, demand for materiel and supplies spurred industrial expansion at home. The city's mills and factories turned out machinery, castings, bar and structural iron, nails and spikes, railroad equipment, and stoves. The federal census of 1870 reported that more than 10,000 men, women, and children were working in Cuyahoga County's 1,149 "manufacturing establishments."

With its web of rail lines and strategic location on Lake Erie, within easy reach of raw materials and markets, Cleveland became a magnet for entrepreneurs, industrialists, and inventors. The prosperity they found here could be seen on Euclid Avenue—Millionaires' Row—which became famous as one of the most beautiful streets in America. Here was a panorama of stately mansions and impeccable landscapes, home to Cleveland's native-born aristocracy—the Wades, Nortons, Mathers, Rockefellers, Stones, Holdens, and Hannas. Its smaller counterpart could be found on Franklin Boulevard on the West Side. Huddled close by and fanning out in a broad arc on the level lake plain were the small gable-roofed cottages of the city's laborers.

As Cleveland industrialized, its population exploded. In the space of four decades, between 1860 and 1900, it grew from 43,417 to 381,768. Germans, Irish, and English—the first groups to come in large numbers—were joined, after 1880, by large numbers of Czechs, Hungarians, Poles, Slovaks, Slovenes, Italians, and Russian Jews. Most came from agricultural societies and readily filled the city's insatiable demand for unskilled labor. They commonly settled near their fellow countrymen, forging distinct ethnic neighborhoods—Warszawa, the Angle, Big Italy, Little Italy, Birdtown, Buckeye, and others. They built

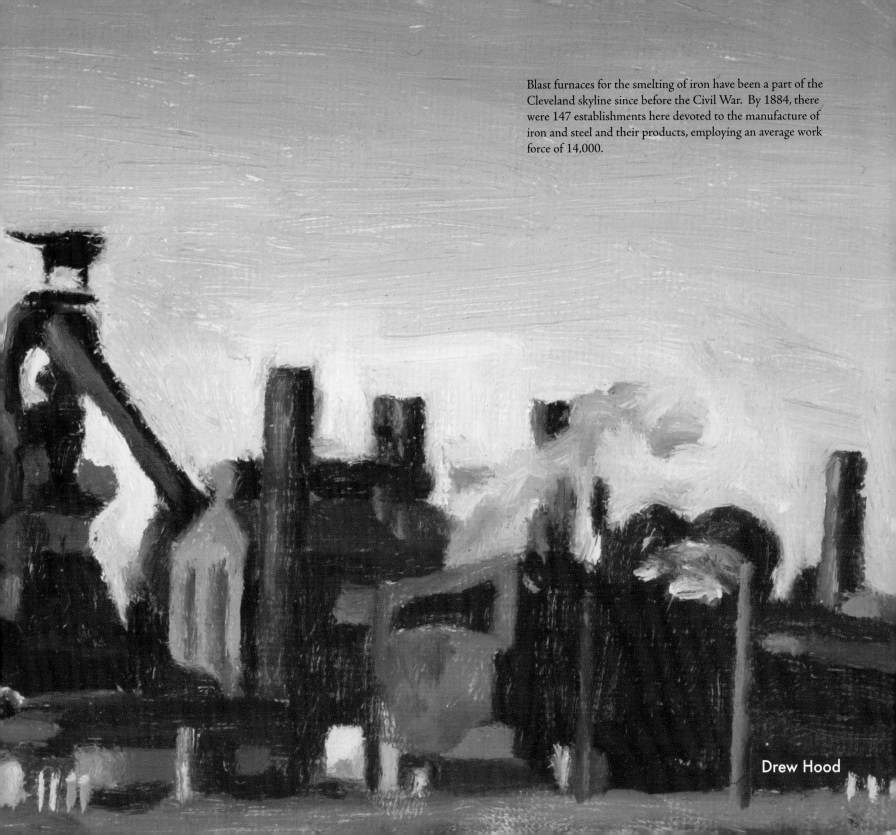

Blast furnaces for the smelting of iron have been a part of the Cleveland skyline since before the Civil War. By 1884, there were 147 establishments here devoted to the manufacture of iron and steel and their products, employing an average work force of 14,000.

Drew Hood

churches of astonishing beauty and sought solace in foreign-language newspapers, cafes, and social clubs. Grinding work, long hours, and low wages were their common lot—conditions that, as the century wore on, led to increasing, sometimes violent, labor unrest and fitful attempts at unionization. With no safety nets, economic downturns caused acute suffering, as during the Panic of 1893, when the printer Max S. Hayes observed that Cleveland was "fairly overrun with idle men … begging for work and food from door to door."

Cleveland was challenged to provide an infrastructure commensurate with its place among the nation's leading cities. It established a waterworks in 1856, a public market house in 1857, and paid police and fire departments in the 1860s. Other projects lagged. When the *Cleveland Daily Herald* proclaimed, in 1878, "Vive la Viaduct! It is finished," it was with a sigh of relief. Cleveland at last had a "high-level" viaduct bridging the deep divide of the river valley, but the new span had been realized only after a decade of injunctions and bitter debate. Similarly, though Cleveland's first board of park commissioners was created in 1871, it did not take meaningful steps toward establishing public parks until the 1890s, when some 1,200 acres, much of it donated by prominent citizens, were transformed into romantically landscaped "pleasure grounds" with winding carriage drives and picturesque lakes. But by then, this much-needed green space was far away from the most crowded neighborhoods.

A Progressive City

After decades of mediocre and often corrupt municipal management, Cleveland in 1901 elected Tom L. Johnson as mayor. The charismatic Johnson, a two-term congressman and progressive reformer, had come to Cleveland in the 1870s as a street-railway investor and operator. He now used his firsthand knowledge of the corrupt alliance between big business and machine politicians to fight monopolies and spoils men. Holding popular "tent" meetings around the city, he communicated directly with citizens, bringing the working class into political life for the first time. He championed women's suffrage, home rule for Ohio's cities, just taxation, and municipal ownership of utilities, including streetcars. In his autobiography (*My Story*, 1911), Johnson would later characterize his efforts as part of a worldwide movement: "the struggle of the people against Privilege."

Under Johnson, who served until 1909, city government contributed as never before to the health and happiness of its citizens, leading the journalist Lincoln Steffens to declare Cleveland "the best governed city" in the nation. It built playgrounds and bathhouses in the most crowded neighborhoods. It built baseball diamonds and basketball and tennis courts, and sponsored

Sunday band concerts in the parks, where Johnson ordered all "Keep off the Grass" signs removed. It built a model workhouse and reformatory, and adopted a modern building code. Johnson appointed a market house commission to plan a new West Side Market (opened in 1912) and proposed the construction of a municipal electric light plant (completed in 1914). Perhaps the most ambitious and enduring legacy of Johnson's tenure was the Group Plan of 1903. Under the direction of a commission headed by Chicago architect Daniel Burnham, the plan envisioned the clearance of a squalid area northeast of Public Square and its replacement with a symmetrical grouping of public buildings in the style of great European cities. A fine civic center gradually was realized, with neoclassical federal and county courthouses, public library, city hall, public auditorium (said to be "the most complete convention hall in the world"), and school administration buildings grouped around a green axis Clevelanders called "the Mall."

A century hence, it is impossible to imagine the Cleveland of 1910—a dense and vibrant city, sixth-largest in the nation. In a single decade, its population had almost doubled (from 381,768 to 560,663). Its territorial reach had spread to embrace the adjoining municipalities of Glenville, South Brooklyn, and Collinwood, prompting the city to impose order by substituting numbers for the names of north-south streets. The Cleveland Industrial Exposition of 1909 boasted of the city's preeminence as a manufacturing center—a boast backed up by the federal census, which showed that metropolitan Cleveland had more than 2,200 plants and factories and ranked seventh nationally in the value of its products. Iron and steel, foundries and machine shops, automobiles and automobile parts, slaughtering and meatpacking, men's and women's clothing, printing and publishing, paint and varnish: Cleveland was one of the world's great industrial centers.

A robust economy, together with the continuing influx of immigrants seeking work, fueled a building boom. Downtown Cleveland mushroomed with elegant office buildings and department stores, palatial banks and arcades. South of Public Square sprawled a vast and cacophonous market district, with two large market houses—the Central and Sheriff Street Markets—doing business amid a web of wholesalers, retailers, and draymen. In the golden age of the speculative developer, newly platted city blocks filled with two-story wood-frame houses and brick apartment buildings. Stores rose along streetcar lines and clustered at transfer points. Fifty-fifth and St. Clair, Five Points (Collinwood), 55th and Broadway, and West 25th and Lorain were the shopping centers of their day. Working men and women lightened harsh lives with excursions by streetcar to Luna Park or Euclid Beach Park, ice skating at the

Architect Marcel Breuer's 1966 addition to the Cleveland Museum of Art was a visually arresting counterpoint to the neoclassical original of 1916.

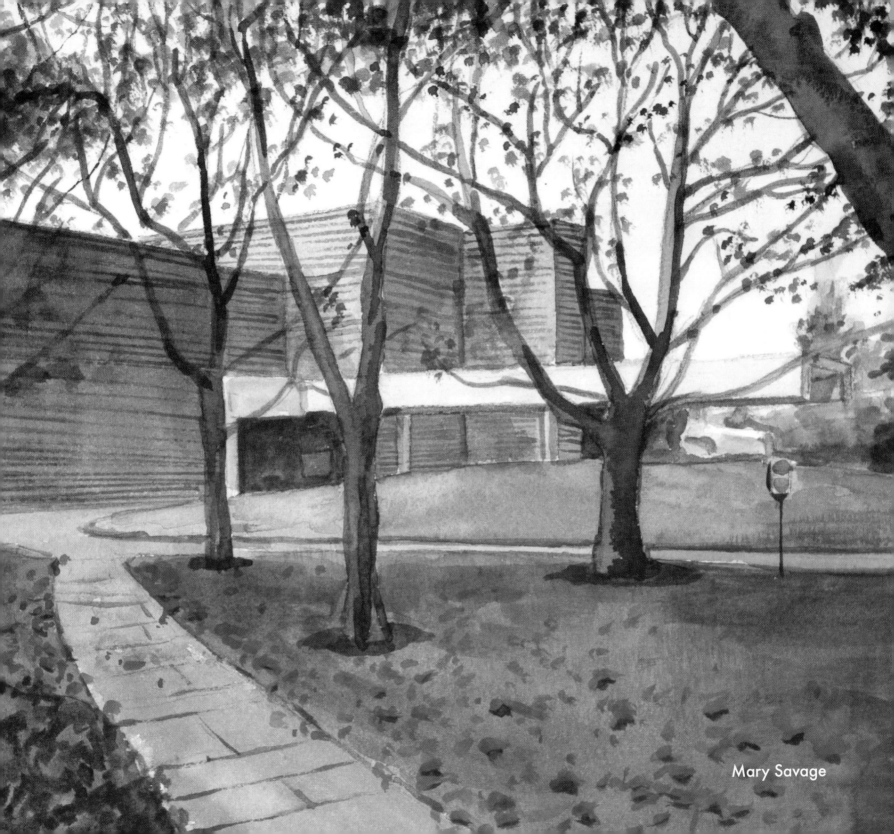

Mary Savage

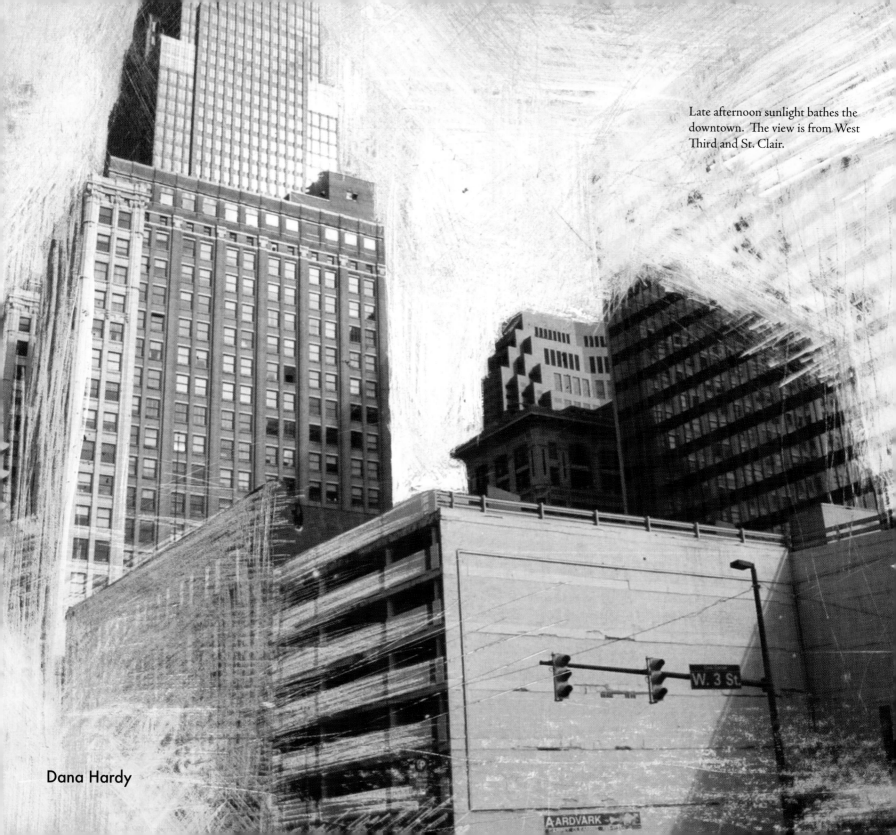

Late afternoon sunlight bathes the downtown. The view is from West Third and St. Clair.

Dana Hardy

Elysium, or professional baseball games at League Park in Hough. Progressive and generous citizens, meanwhile, established settlement houses, medical and legal clinics, orphanages, and branch libraries. The Board of Education erected handsome and substantial school buildings in every neighborhood to educate and "Americanize" the children of a polyglot city.

Cleveland's commercial, industrial, and civic momentum inspired a deep and genuine pride that can be heard in the messages scrawled on picture postcards of the period:

On a view of Public Square, 1908: "This great square is I think as busy a place as I know of…. Hundreds of cars both city & Interurban start from here and there is probably nothing like it in the world."

On another view of Public Square, 1908: "You would hardly know Cleveland if you have not been here for some time. There are ever so many new skyscrapers since then."

On an undated view of the Williamson Building (then the tallest in the state): "Dear Grandma, It is snowing like everything and cold as Greenland, but we are taking in the big stores."

On a view of Lake View Park (on the site of the present City Hall), 1905: "There are the greatest lot of bridges here you ever saw."

On a view of the stone-arch Superior Viaduct and the smoke-shrouded Flats, 1907: "This is a great sight."

On a view of the Rocky River Bridge, 1911: "I write a few lines to let you know that Cleveland is the place to live."

Ironically, Cleveland's industrial growth and prosperity were sowing the seeds of decline. By 1910, the scions of Millionaires' Row began to flee an increasingly choked and befouled city center. They retreated to new mansions along the lake shore or in the Heights, bringing an end to a storied avenue. Yet even as they departed, these "Edwardian men in dinner suits and plain, intelligent women in great-girthed brocaded gowns" (Eleanor Munro, *Memoir of a Modernist's Daughter*, 1988) endowed important benevolent and cultural institutions. The Cleveland Orchestra, the Cleveland Museum of Art, Karamu House, the Cleveland Clinic, the Cleveland Play House, the Cleveland Institute of Music, and the Cleveland Museum of Natural History—all were founded in a single bountiful decade.

It was an era not only of philanthropy but civic vision. Perhaps no one was more prescient than William Stinchcomb. As a young civil engineer working for the city, Stinchcomb foresaw the future need for open space as early as 1905. He suggested "establishing an outer system of parks and boulevards" before development and rising land costs put such a plan beyond reach, leading to the creation, in 1917, of the Cleveland Metropolitan Park District. Stinchcomb went on to guide metropolitan park development and operations for half a century, leaving an "Emerald Necklace" of reservations and parkways, and a legacy of incalculable delight for generations of Clevelanders.

America's entry into the First World War, and the restrictive legislation that followed, brought an abrupt end to large-scale European immigration. To fill the need for manual laborers, Northern industries began recruiting Southern blacks, offering free train fare and the promise of good jobs. News of a better life in the North triggered a mass movement that has come to be called the "Great Migration." In Cleveland, the number of African-Americans soared from 8,448 in 1910 to 71,899 by 1930.

In the nineteenth century, blacks in Cleveland had been generally integrated residentially, and integrated restaurants, lecture halls, schools, and other public facilities were the norm. Conditions changed with the massive influx of newcomers largely unaccustomed to urban life. Central Avenue, between Euclid and Woodland, which had housed the largest number of blacks before the war, became the heart of a crowded black ghetto, with higher rates of crime and disease than other areas of the city. Blacks increasingly experienced discrimination and unequal treatment, paying, according to a 1917 Chamber of Commerce report, 65 percent more than whites for comparable housing. In *The Big Sea* (1940), the writer Langston Hughes, who attended Cleveland's Central High School, recalled having lived "either in an attic or basement" and paying dearly for such quarters: "White people on the east side of the city were moving out of their frame houses and renting them to Negroes at double and triple the rents they could receive from others. An eight-room house with one bath would be cut up into apartments and five or six families crowded into it."

A world away, meanwhile, on high ground southeast of the city, two shy and reclusive bachelor brothers were developing Shaker Heights, a model residential suburb of romantic period houses linked by high-speed rail transit to Public Square. Oris Paxton Van Sweringen and Mantis James Van Sweringen also cleverly maneuvered to have the railroads build a desperately needed downtown passenger station that would provide the foundation for a stunningly ambitious commercial development using the air rights above. The Cleveland Union Terminal complex, dedicated in 1930, was a sophisticated "city within a city," comprising office buildings (including the fifty-two-story Terminal Tower), a hotel, a large department store, central post office, stores, and restaurants. But even as the landmark skyscraper rose—proving an irresistible subject for the young photographer Margaret Bourke-White—the city's economic fortunes were spiraling downward.

A City in Decline

Forty-one thousand jobless in April 1930 swelled to 100,000 by January 1931. With its social welfare agencies over-taxed, Cleveland, like the rest of America during the Great Depression, looked to the federal government for help. Federal work relief projects aided jobless families at the same time that they left a visible legacy of park development, new roads and bridges, and public art. Between 1935 and 1937, the Public Works Administration Housing Division

built the first public housing in the nation in Cleveland: Lakeview Terrace, on the near West Side; and Cedar-Central and Outhwaite Homes, on the near East Side. As the grip of economic depression eased, the Great Lakes Exposition (1936-1937) helped lift the city's spirits, as did completion of the Group Plan, born of long and patient effort.

World War II fortified Cleveland's economy with a massive industrial expansion that carried over into peacetime. Seeking work, Southern blacks continued to migrate to Cleveland in large numbers, together with large numbers of Puerto Ricans and people fleeing the depressed areas of Appalachia. With the opening of the St. Lawrence Seaway in 1959, connecting the Great Lakes with the Atlantic Ocean, the city was poised to become a "World Port." Civic boosters adopted the electric company's happy boast that Cleveland was "the best location in the nation." But potent forces already had begun to erode its well-being.

"Most people who live in Cleveland are anxious to move to the suburbs," the Chamber of Commerce had declared in a 1941 report on the problem of "decentralization." Out-migration of the middle class had been under way since well before 1920, when such suburbs as Cleveland Heights, Shaker Heights, and Lakewood saw intensive residential development. But further large-scale migration had been forestalled, first by the Depression, then by shortages of men and materials during World War II. At war's end, however, new subdivisions mushroomed in Brooklyn, Parma, Maple Heights, Mayfield Heights, and other suburbs, encouraged by federally insured mortgages and a massive program of federally financed highway construction. The suburbs were siphoning off commerce, industry, and people, and Cleveland—with slums "as vast and as wretched as are to be found anywhere in the country," according to the *Plain Dealer*—was rotting at the core.

Mayors Anthony J. Celebrezze and Ralph Locher, earnest and well-meaning men, presided over a city in the midst of bewildering change. They maintained a minimum level of city services, kept taxes low, cultivated their white ethnic political base, and oversaw the largest urban renewal program in the nation. Large areas of the East Side were razed for the purpose of attracting new private development for which, it turned out, there was no market. Of the city's seven urban renewal areas, only the downtown Erieview project resulted in significant new investment. There, the project's first building—a forty-story-tall, green-glass-clad office tower completed in 1964—stood as a dramatic symbol of hoped-for renewal. Other new buildings would gradually follow, creating a modern office and financial district with Ninth Street as its spine.

Outside the downtown, however, no such renewal occurred. Further, the consequences of large-scale demolition had not been anticipated. Those displaced by urban renewal—overwhelmingly black and poor—moved into other East Side neighborhoods, triggering white flight. The Hough area, two miles east of Public Square, underwent such rapid social change that it became a subject of academic study. Poor, overcrowded, crime-ridden, redlined, deteriorating, and restive, Hough boiled over in July 1966 with an outbreak of racial violence that left four dead and millions of dollars of property damage. Mayor Locher described the rioting as a "tragic day in the life of our city." With images of the Ohio National Guard patrolling its streets broadcast nationwide, Cleveland stood as the very symbol of America's "urban crisis."

The Hough riots instilled profound feelings of fear and futility in Clevelanders. Notwithstanding the election of the city's first black mayor, Carl B. Stokes, in 1967, the racial divide appeared to be an unbridgeable chasm, political infighting a permanent way of life. Then, on June 22, 1969, the Cuyahoga River caught fire, dramatizing the extent of the stream's pollution and once again holding Cleveland up to national opprobrium. Things only got worse. By the early 1970s, some 20,000 people were leaving the city each year; streets where people once lived and shopped now stood empty. "Location" no longer was the advantage it once had been. Industries were abandoning obsolete multistory factories along the rail lines in favor of one-story plants near freeways, or leaving the area altogether. A 1975 Brookings Institution study ranked Cleveland second among big cities having the worst social and economic problems. But there was deep psychological hurt too. Cleveland, a once-proud city, was now the butt of jokes—the place where the river burned, the "mistake on the lake."

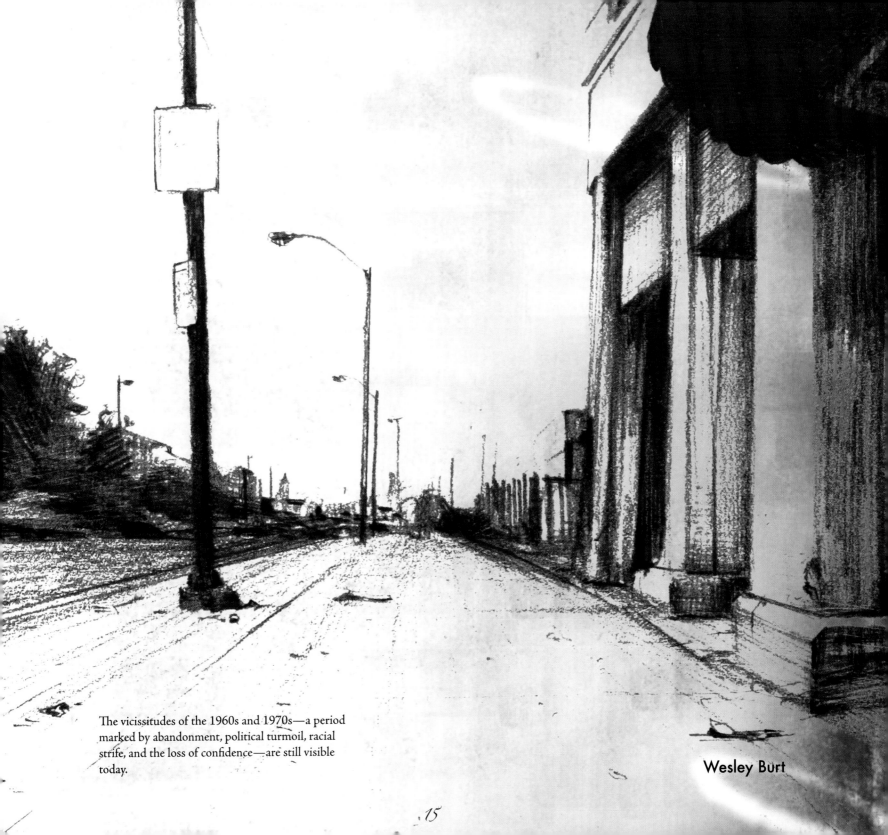

The vicissitudes of the 1960s and 1970s—a period marked by abandonment, political turmoil, racial strife, and the loss of confidence—are still visible today.

Wesley Burt

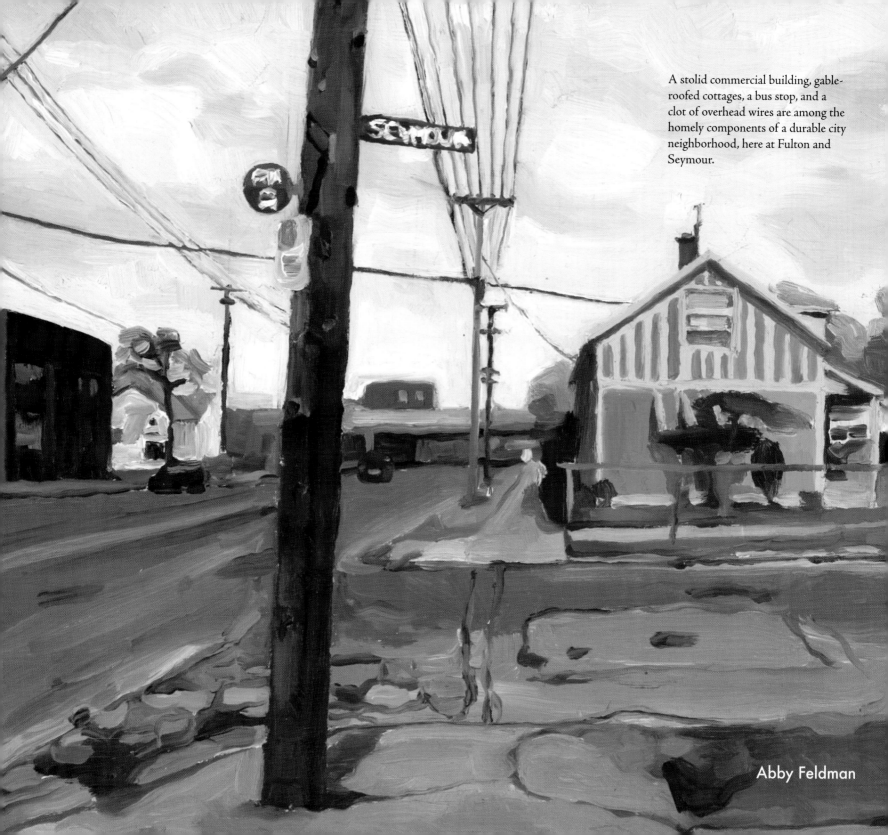

A stolid commercial building, gable-roofed cottages, a bus stop, and a clot of overhead wires are among the homely components of a durable city neighborhood, here at Fulton and Seymour.

Abby Feldman

Comeback

In 1976, the federal court ordered the desegregation of the 123,000-pupil Cleveland school district. The remedy, cross-town busing, accelerated the flight to the suburbs. Anyone having the wherewithal—blacks as well as whites—moved out, further diminishing an already eroded tax base. As Mayor Ralph J. Perk sought to stem revenue shortfalls by selling city assets and boost development downtown by awarding lucrative tax abatements, a brash young opponent successfully challenged these strategies. In 1977, Councilman Dennis Kucinich was elected mayor. Although his tenure was short-lived and marred by the city's financial default and an unsuccessful effort to recall him, Kucinich realized a notable victory by halting the sale of the city-owned electric utility to the private Cleveland Electric Illuminating Company. "Power to the People" declared a sign installed atop the Muny Light plant. T-shirts appeared depicting a muscular skyline and reading, "Cleveland—you've got to be tough!"

Some, in these dark years, took up projects of meaningful renewal. Ray K. Shepardson championed the preservation of a group of old movie and vaudeville houses threatened by the wrecking ball. He formed the Playhouse Square Association and mounted a musical production, *Jacques Brel Is Alive and Well and Living in Paris*, that captured the public's imagination and won converts to his vision that, restored to glory and reused, the theaters had the capacity to revive downtown Cleveland. In the Flats, where Moses Cleaveland and his party had disembarked almost two centuries earlier, latter-day pioneers began turning old waterfront buildings into bars, restaurants, and shops. Adventurous young urbanites could nurse drinks as they watched an amazing show of moveable bridges and tug-guided ore boats making their way to and from the steel mills upriver. With their authentic appeal and wealth of sturdy buildings, Cleveland's riverfront and the adjacent historic Warehouse District became the focus of commercial and residential redevelopment. Meanwhile, efforts to create the Cuyahoga Valley National Recreation Area (now Cuyahoga Valley National Park) resulted in the preservation of a critical green corridor between Cleveland and Akron, including the remains of the Ohio & Erie Canal. Made over into a recreational trail, the old towpath quickly became a popular destination for joggers and bicyclists.

Like other rust-belt cities, Cleveland underwent wrenching economic change as industries cut back and restructured. Many in its traditional blue-collar work force were left behind as manufacturing employment fell precipitously and the emerging service economy supplied new but fewer and less well-paying jobs. Meanwhile, the complexion of Cleveland was changing as the proportion of its African-American population grew dramatically (44 percent by 1980). Though some traditional European groups, such as Poles and Italians, remained a visible presence, others dispersed as sons and daughters moved to the suburbs. Migration did not stop—its pattern changed, especially in response to international politics. Now, Asians (including the first Vietnamese) and Latinos arrived, many settling in the old "ports of entry"—the near East and near West Sides.

Aided by generous public subsidies, downtown development surged beginning in the late 1980s. New office buildings rose, including one—Society (now Key) Tower—that eclipsed the landmark Terminal Tower as the city's tallest. Developers appended the glass-roofed Galleria at Erieview, with two levels of stylish shops, to Erieview Tower, and gutted the bowels of the Terminal Tower for Tower City Center, encompassing retail stores, offices, a rebuilt transit station, and a luxury hotel. Hoping to mimic Baltimore's successful Inner Harbor development, Cleveland carved out an artificial harbor on the downtown lakefront. North Coast Harbor eventually became the site of the Rock and Roll Hall of Fame Museum, for which Clevelanders waged a vigorous campaign (and footed most of the $90 million cost).

In the 1990s, Cuyahoga County taxpayers financed the construction of costly new homes for each of Cleveland's professional sports teams. To mark Cleveland's bicentennial, in 1996, the city built a new rapid transit line connecting North Coast Harbor with the Flats and Tower City Center. Amid this downtown transformation, there was a palpable sense that Cleveland had rebounded. Civic leaders promoted Cleveland as the "Comeback City," a theme picked up by the national press. Mayor Michael R. White, who presided over most of these large projects, proudly asserted that "Cleveland is looked upon as a model for what can be accomplished in urban America."

Postscript

In 2005, Cleveland's resurrection looked less secure. Solutions to longstanding problems—unemployment, population loss, struggling schools—were elusive. In the new global economy, Cleveland continued to lose business and industry. Euclid Avenue stood eerily empty; even audiences for the performing arts were shrinking. As civic leaders contemplated the implications of what the *Plain Dealer* called a "quiet crisis," the U.S. Census Bureau named Cleveland, with a poverty rate (2003) of 31.3 percent, the nation's poorest city.

While some continued to look to large projects for answers—downtown casinos, a new convention center—others pursued small-scale efforts focused on neighborhood renewal, education, public health, and improving the quality of everyday life. "We can be a green city on a blue lake," declared EcoCity Cleveland, an environmental group. The simple but compelling vision recalled Cleveland's onetime, half-forgotten title—the "Forest City"—even as it suggested a possible vision for its third century.

For all its problems, Cleveland in 2005 remained a city of hard-edged beauty, with an authentic visual landscape. Its history could be seen in its face—in broken yet tenacious neighborhoods, weathered factories, gritty streets, a crooked river, a hardy people. The homely composite spoke volumes about the heart and spirit and tenacity of our town.

In 2005, some Clevelanders looked to a remade waterfront and a new convention center to revive the city's economic fortunes.

18

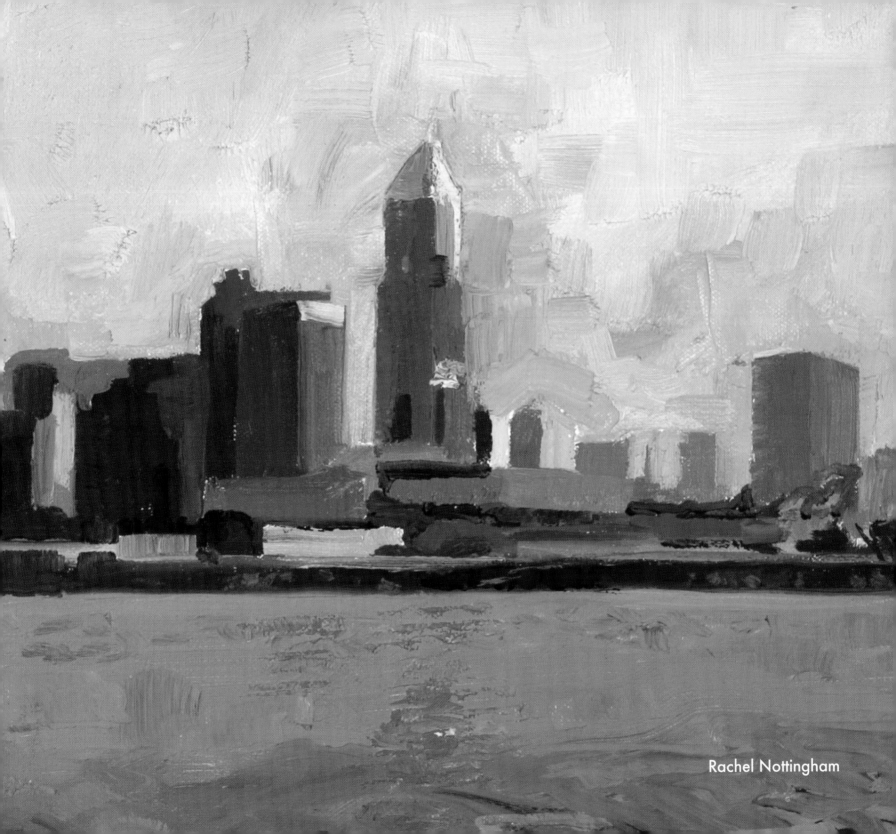
Rachel Nottingham

Abby Feldman

Christi Birchfield

Dana Hardy

Clockwise from top:
In Edgewater Park. The initial acreage for the lakefront park was purchased in 1894, following the adoption of the first general plan for park development in Cleveland.

In Slavic Village, simple workers' cottages form an intimate huddle.

West Sixth Street, in the Warehouse District, enjoys a lively nightlife.

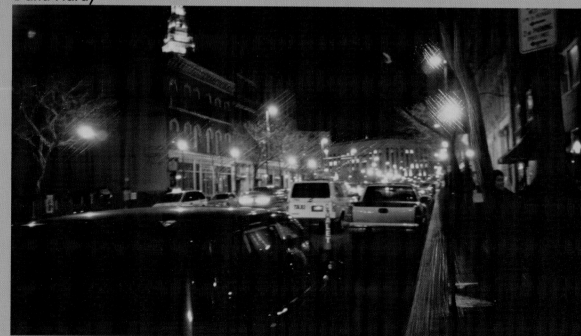

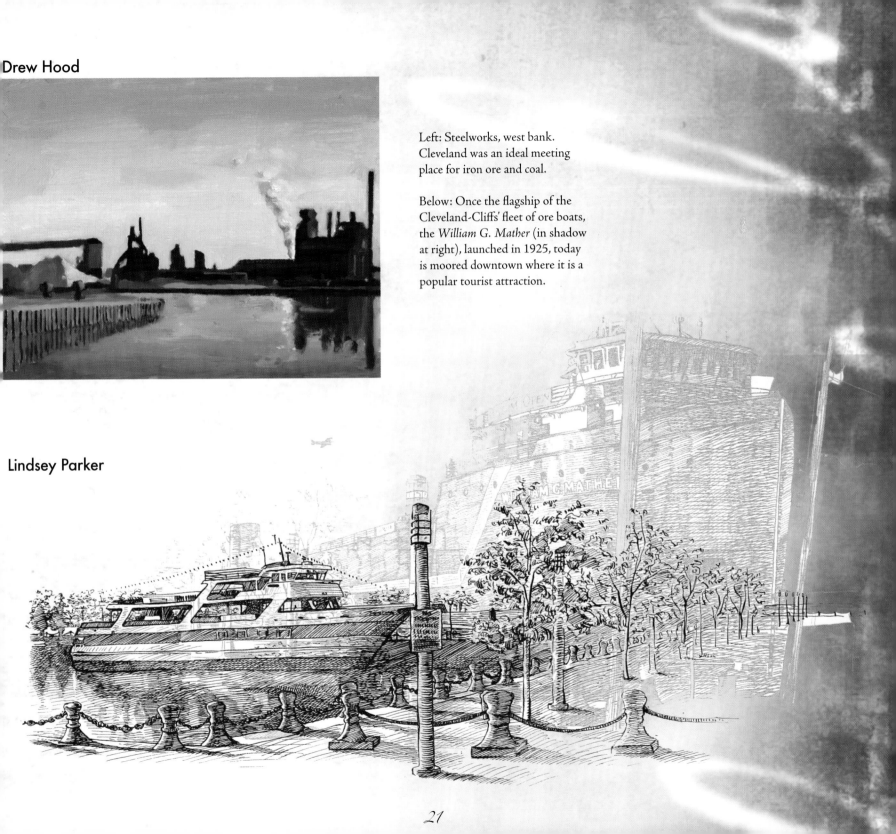

Drew Hood

Left: Steelworks, west bank. Cleveland was an ideal meeting place for iron ore and coal.

Below: Once the flagship of the Cleveland-Cliffs' fleet of ore boats, the *William G. Mather* (in shadow at right), launched in 1925, today is moored downtown where it is a popular tourist attraction.

Lindsey Parker

21

Chris Jungjohann

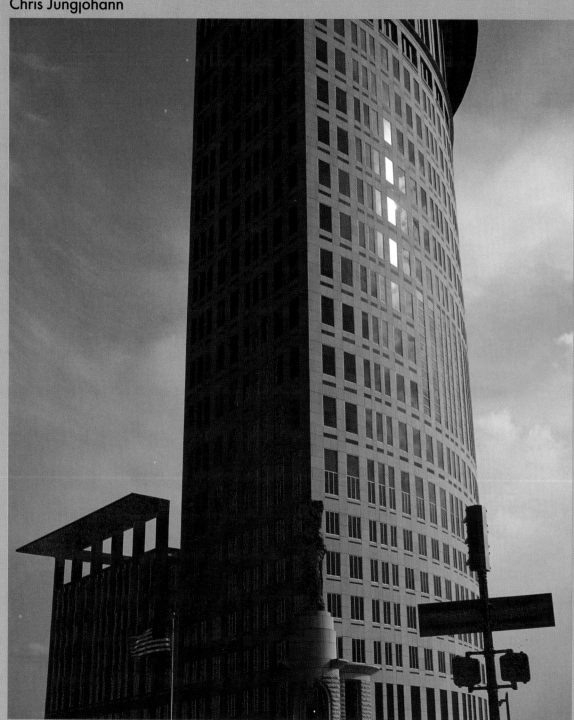

Left: Named for former Cleveland Mayor Carl B. Stokes and opened in 2002, the striking new federal courthouse marks the western gateway to downtown.

Right: Whipp's Ledges, Hinckley Reservation. To this place, in northern Medina County, the "buzzards"—actually, turkey vultures—are reputed to return each year on March 15. The first sighting marks the start of spring.

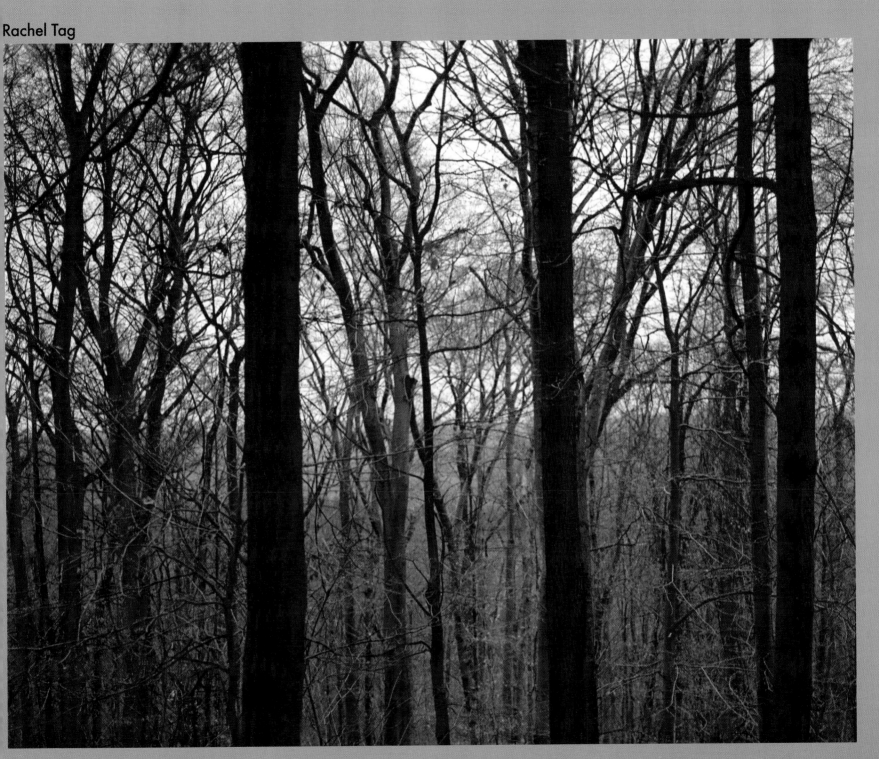

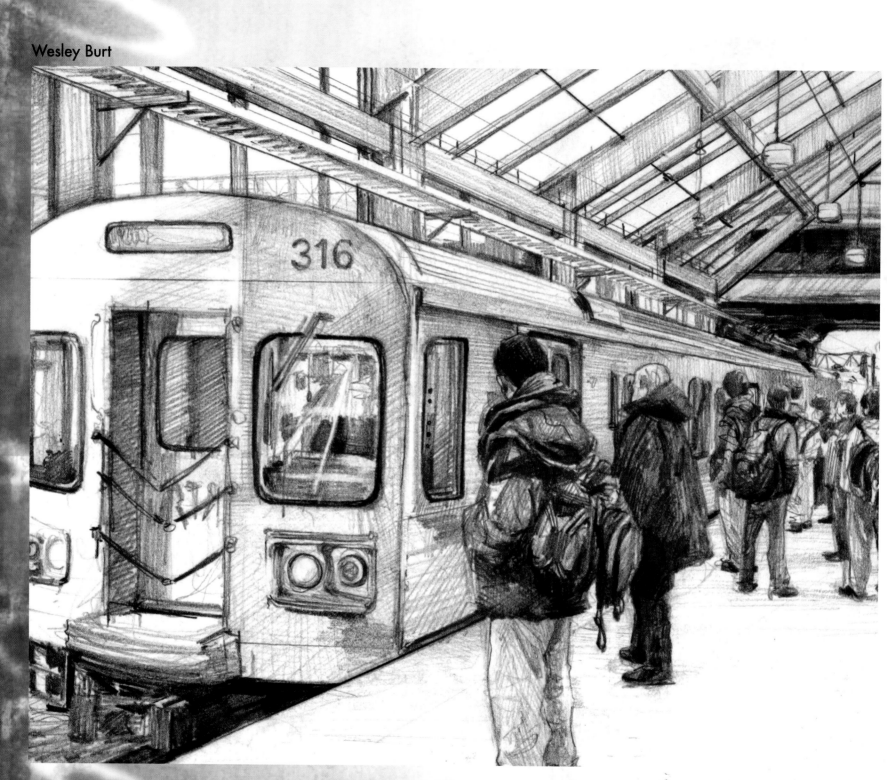

Wesley Burt

Lindsey Alberding

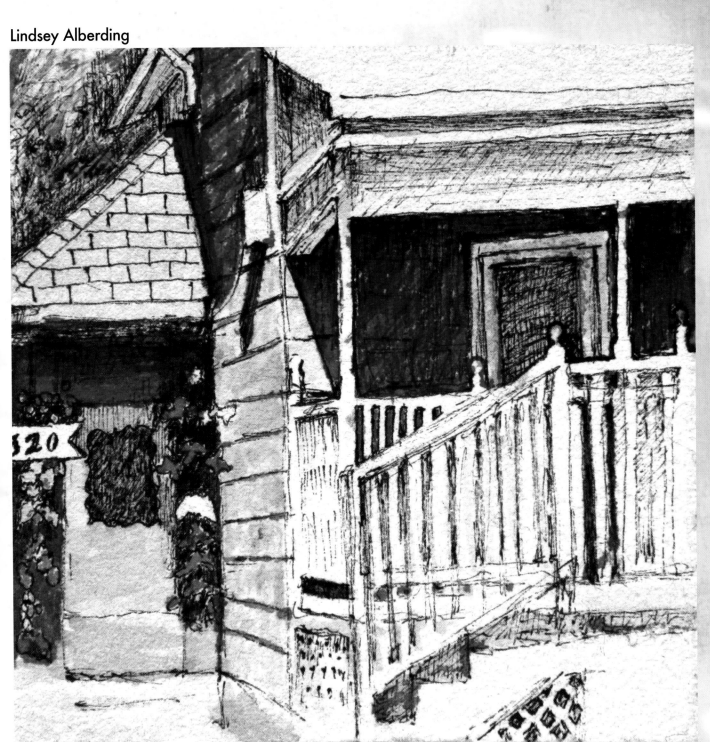

Far left: Waiting for the "rapid" in the glass-roofed Ohio City station.

Left: A house on Carroll Avenue in Ohio City seems to say, "Come, sit, stay awhile."

Nina Barcellona

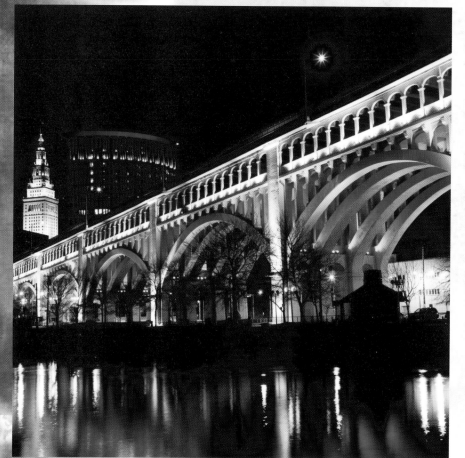

Christi Birchfield

Clockwise from top:
Opened in 1917, the Detroit-Superior High-Level Bridge was the first bridge across the Cuyahoga to allow vehicular and river traffic to proceed at the same time. Streetcars ran on the span's lower deck until 1955.

Nightlife in Cleveland might be a shot and a beer at a neighborhood tavern …

… or live music at a club in the Warehouse District downtown.

Dana Hardy

Mandy Stehouwer

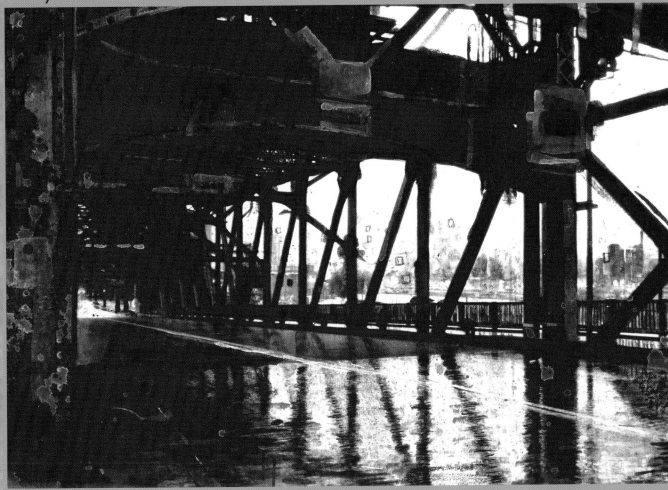

Left: The Columbus Road Bridge, site of the 1837 "Bridge War" between Cleveland and Ohio City, arch rivals until consolidation in 1854. The East-West divide is sometimes still palpable.

Below: Brownfields touched by frost frame the skyline.

Chris Jungjohann

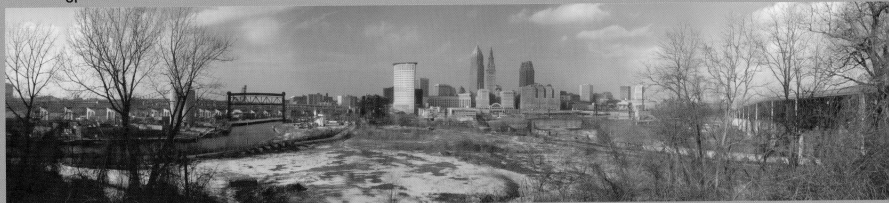

Chris Jungjohann

Wesley Burt

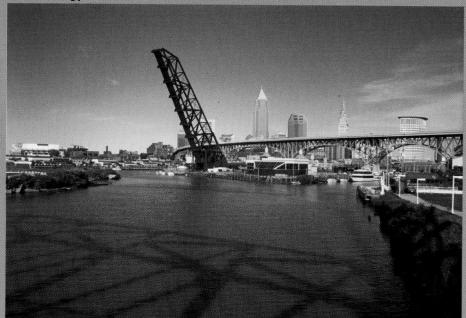

Mandy Stehouwer

Clockwise from top:
Skyline view from the old river channel.

Body shop, Euclid Avenue.

Signs on I-90. Beginning in the 1950's, highway building badly rent some city neighborhoods and hastened migration to the suburbs.

Paul Koneazny

Salvatore Schiciano

Salvatore Schiciano

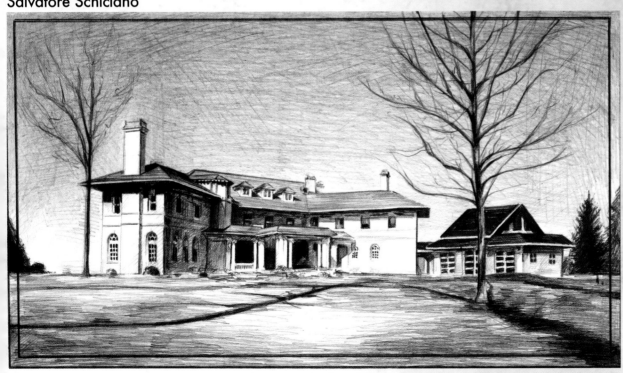

Clockwise from left:
At the turn of the twentieth century, Lake Shore Boulevard in Bratenahl became a destination for wealthy Clevelanders departing Euclid Avenue, the once-famed "Millionaires' Row."

Roofs in Hough.

Gust Gallucci Company, at 6610 Euclid Avenue, does a brisk business in Italian imports.

Cecelia Phillips

Mandy Stehouwer

Dana Hardy

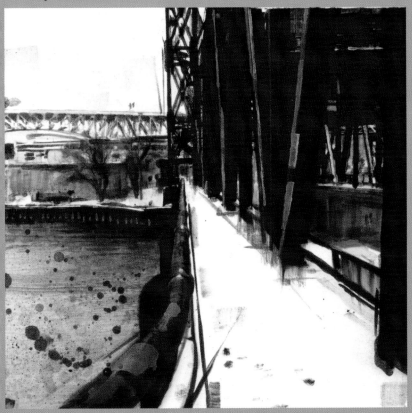

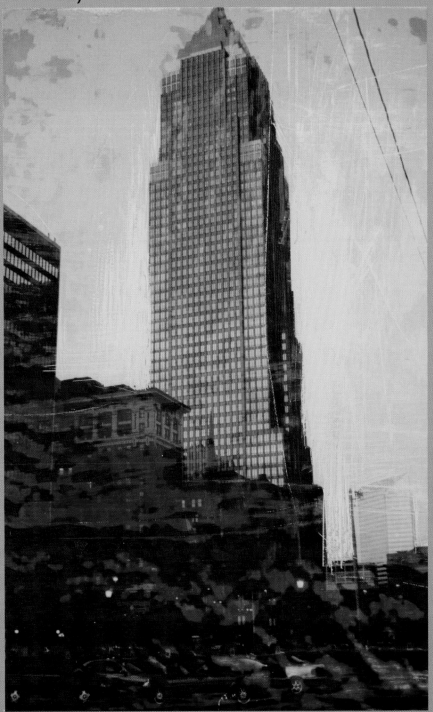

Left: Scene of many legendary "firsts," League Park, on Lexington Avenue in Hough, was the home of major-league baseball from 1891 until 1932, when the schedule gradually shifted to the new Municipal Stadium. It was also the home of the Cleveland Buckeyes, winner of the 1945 American Negro World Series.

Above: The West Third Street Bridge spans the Cuyahoga River near Tremont.

Right: The fifty-seven-story Key Tower (formerly Society Tower) with its adjoining hotel was at the center of a preservation battle. The Society for Savings Building of 1890 was saved; the Brotherhood of Locomotive Engineers Building of 1910—the first building of its kind to be built by organized labor—was not.

Christi Birchfield

32

Albert Beltz

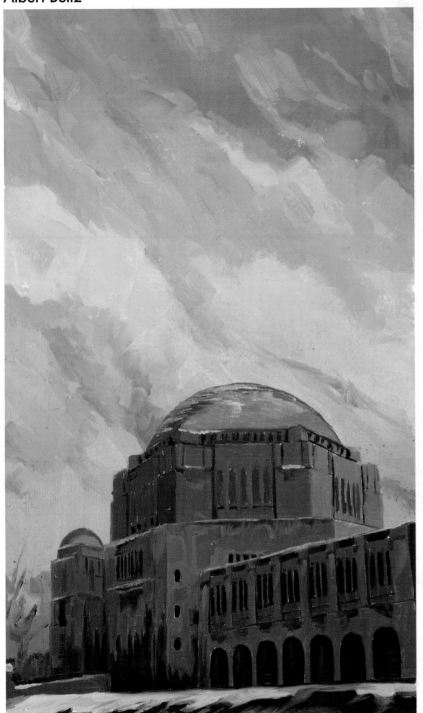

Rachel Nottingham

Far left: West Seventh Street, Tremont. Isolated by highway construction in the 1960s, the Tremont neighborhood has rebounded and today is prized for its historic architecture, ethnic diversity, and small-town ambience.

Left: Temple-Tifereth Israel, known as The Temple, was established in 1850. This, its third home, at Ansel and East 105th near University Circle, served the Reform congregation from 1924 until 1969, by which time most of its members had departed for the suburbs.

Above: A serene lookout on the Lake Erie shore.

Mary Savage

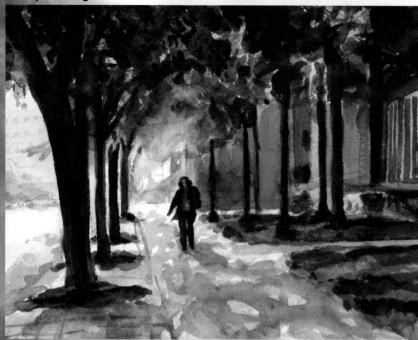

Left: On Ford Drive, on the campus of Case Western Reserve University.

Below: Downtown Cleveland, viewed from Gordon Park. The sky here seems always to be filled with gulls fishing in the warm discharge of a nearby power plant.

Lindsey Alberding

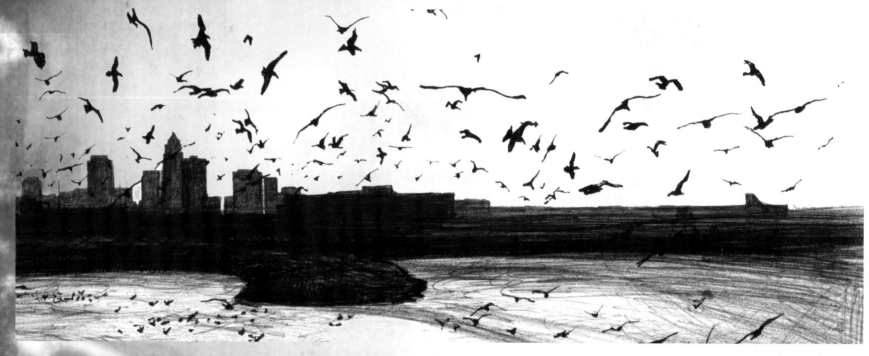

Dana Hardy

Christi Birchfield

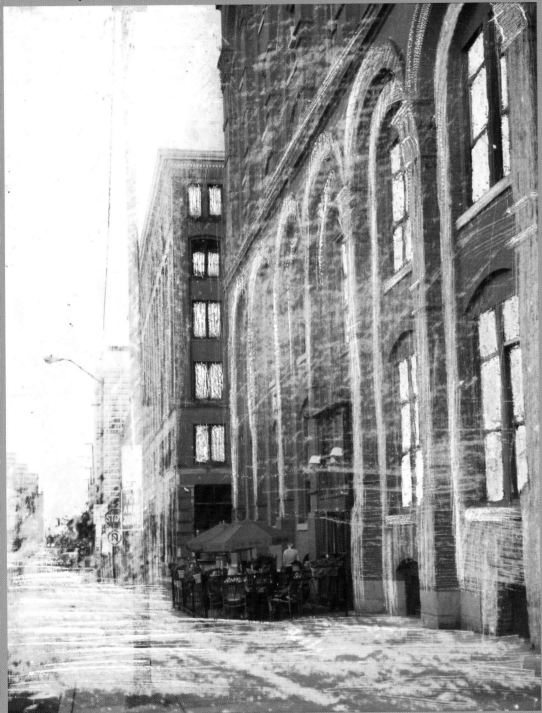

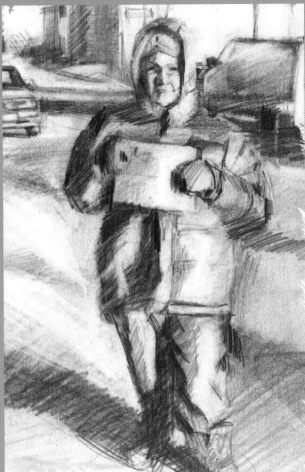

Left: The handsome nineteenth-century buildings of the historic Warehouse District provided the foundation for the neighborhood's revival.

Above: Marsha Rizzo-Swanson, a top seller of *The Homeless Grapevine*. The newspaper gives a voice to the voiceless and provides a way for homeless and low-income people to lift themselves out of poverty.

Rachel Tag

Chris Jungjohann

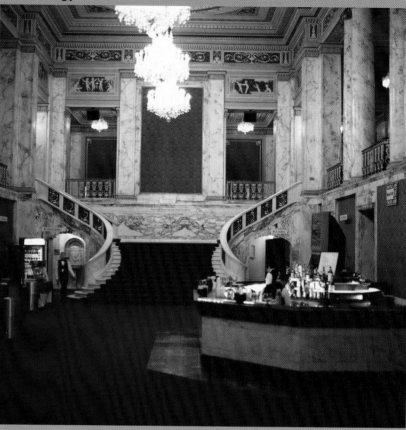

Salvatore Schiciano

Clockwise from bottom left:
Industrial buildings on the near East Side, like these on East 36th Street, were once filled with manufacturing firms. Today some are finding new use as artists' studios and live-work lofts.

Golf course, Cleveland Metroparks.

The sumptuous marble-clad lobby of the Palace Theatre. Flagship of the Keith chain of vaudeville theaters when it opened in 1922, the Palace and three adjoining theaters of the same vintage were nearly reduced to rubble after they closed in the 1960s. Today they are the heart of Playhouse Square, a center for the performing arts.

Right: A cozy trattoria on Mayfield Road in Little Italy.

Wesley Burt

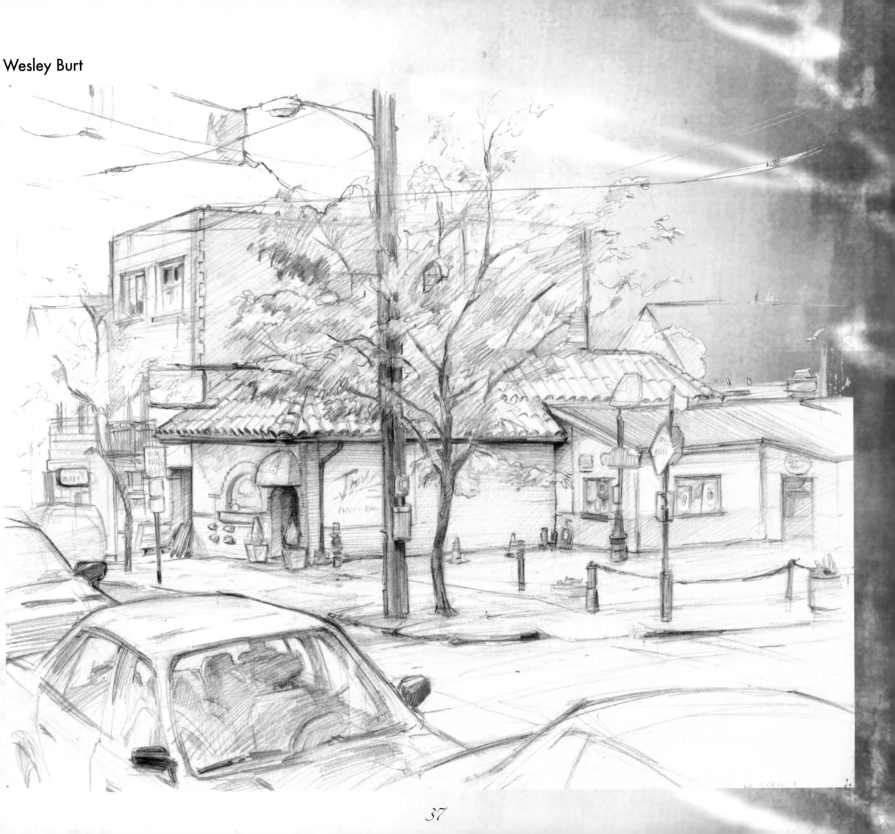

Sarah Laing

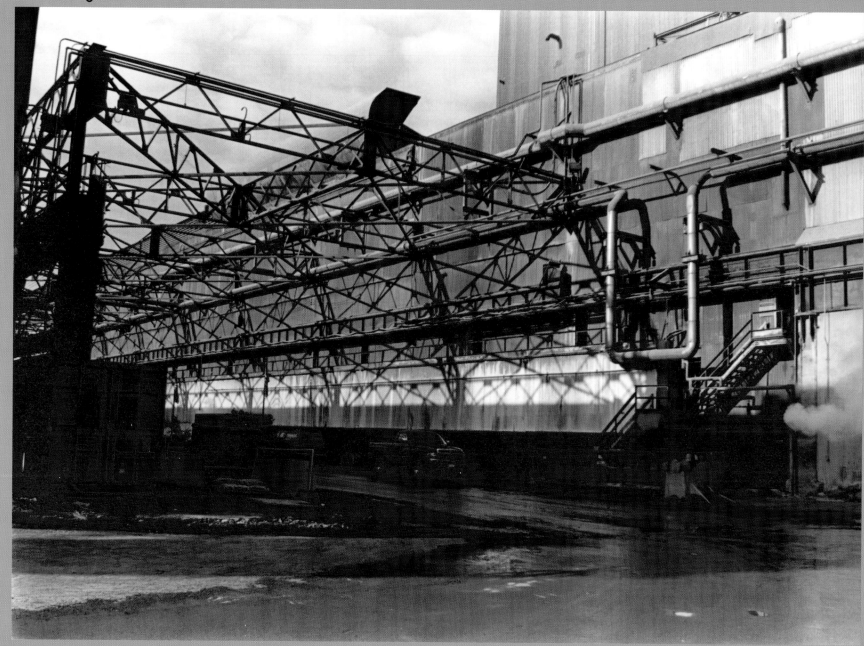

Andrew Zimbelman

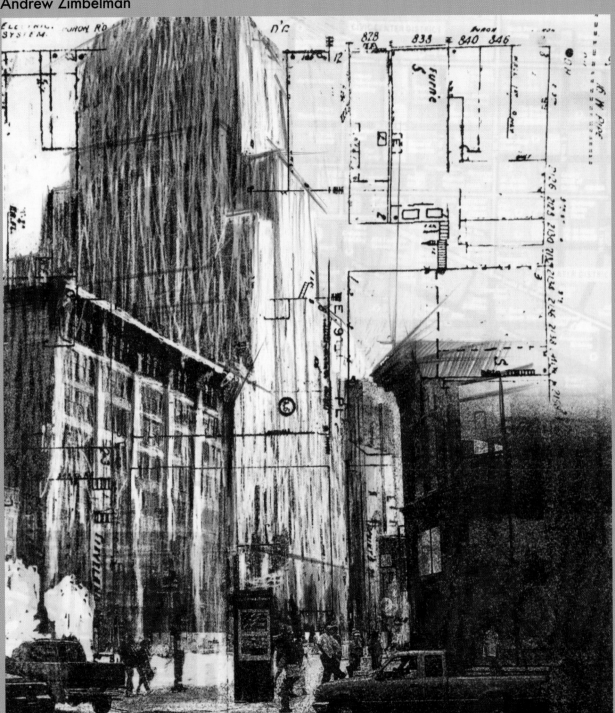

Left: At International Steel Group (now Mittal Steel). Hot- and cold-rolled steel made in Cleveland is used in the manufacture of automobiles, appliances, office furniture, and other goods.

Right: On Huron Road, in what today is known as the Gateway District. Shown here are the Caxton Building (1903), built to house the city's printing and graphic-arts trades, and the modernistic Ohio Bell Building (1927), a rare example in Cleveland of the "setback" style popularized in response to changes in New York zoning laws.

Salvatore Schiciano

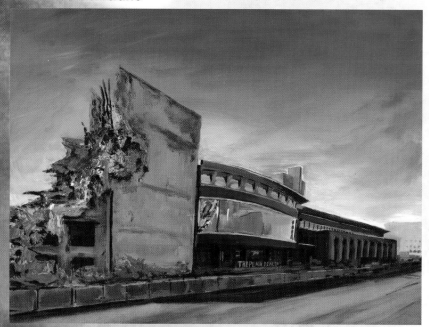

Nina Barcellona

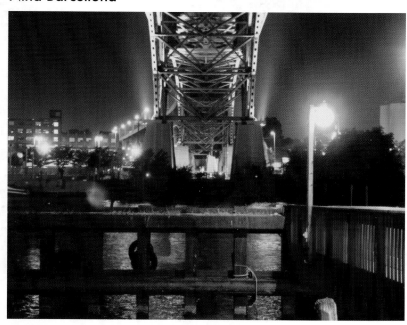

Dana Hardy

Clockwise from top:
The old plant of *The Plain Dealer* makes way for its sleek successor. The new building houses business and editorial offices, but the paper is now printed in Brooklyn.

Underbody of the Main Avenue Bridge.

The Justice Center complex stands benignly against the late-day sky.

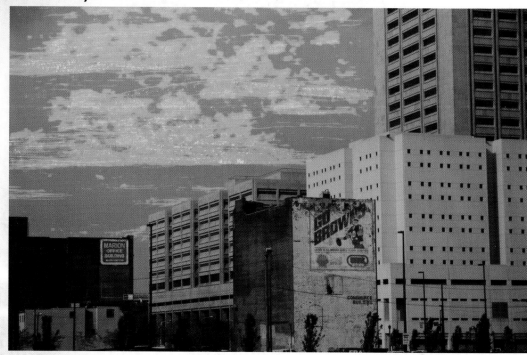

Salvatore Schiciano

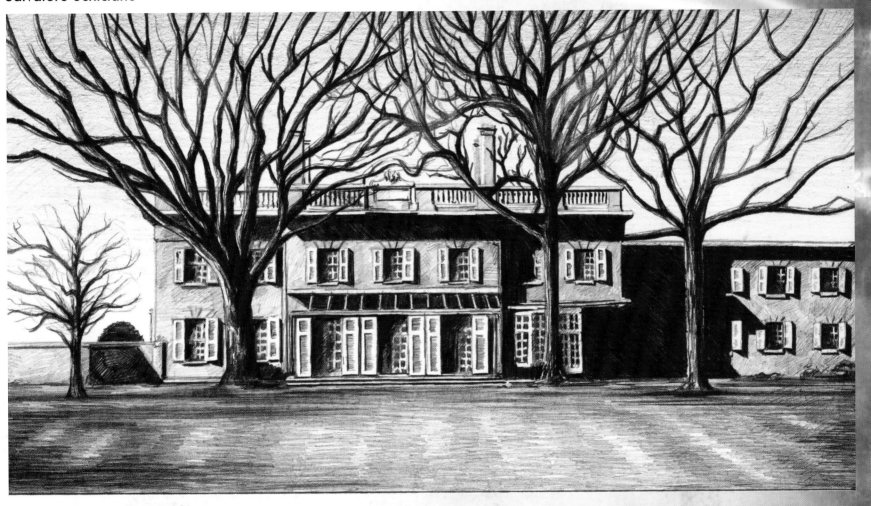

Gwinn (1907), the home of industrialist William G.
Mather, has been hailed as one of the best preserved
estates of the Country Place Era in America, a period
from 1900 to the beginning of World War II. Today the
Bratenahl estate is maintained for use by cultural and
philanthropic organizations.

Drew Hood

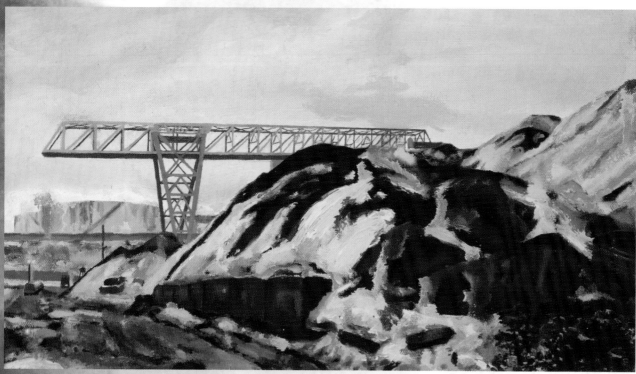

Counter Clockwise from top:
An iron-ore bridge with its winter stockpile.

The twenty-first-century federal courthouse and the nineteenth-century powerhouse of the Woodland Avenue & West Side Railway here appear to be neighbors, but they actually stand on opposite sides of the river.

RTA station near, Settlers' Landing in the Flats.

Right:
Architect Frank Gehry's deconstructed aesthetic can be seen in this glimpse of the Peter B. Lewis Building on the campus of Case Western Reserve University. Opened in 2002, the building houses the Weatherhead School of Management.

Chris Jungjohann

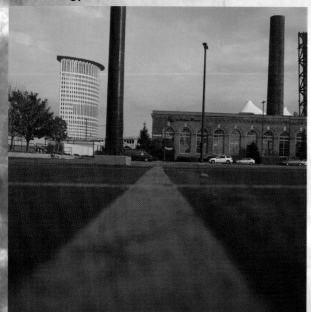

Nina Barcellona

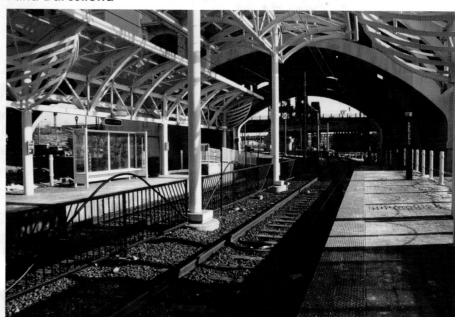

Wesley Burt

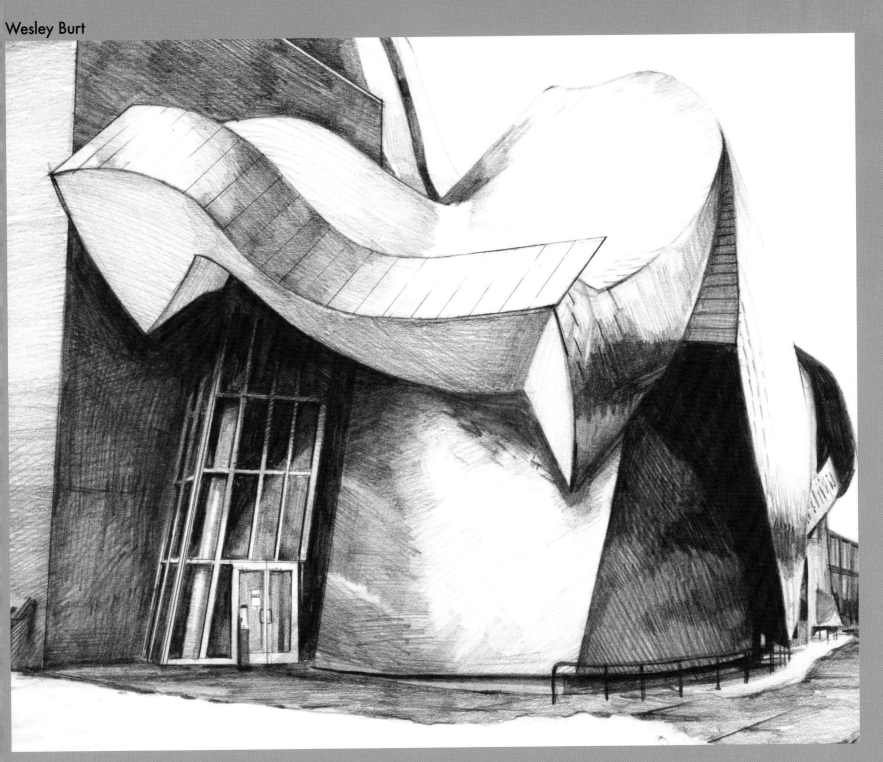

Ben Dewey

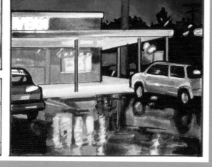

Lindsey Parker

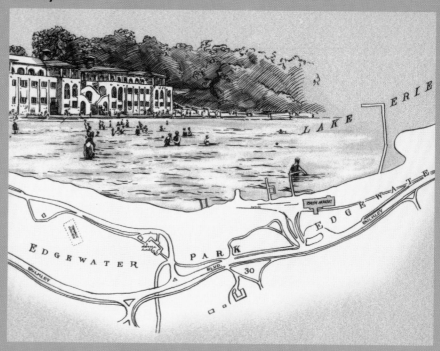

Albert Beltz

Clockwise from top left:
Old Brooklyn portrait: Buzz and Peggy Zeleznik, owners and operators of Zeleznik's Tavern, a favored haunt of steelworkers.

Edgewater Park, 1929. The Spanish Mission-style bathhouse of 1914, since demolished, is said to have accommodated three thousand bathers at a time.

Skipping stones at the lagoon in the Fine Arts Garden of the Cleveland Museum of Art. Industrialist Jeptha H. Wade donated the land to the city in 1882, and Wade Park became the setting for many of Cleveland's important cultural institutions.

Rachel Tag

Rachel Tag

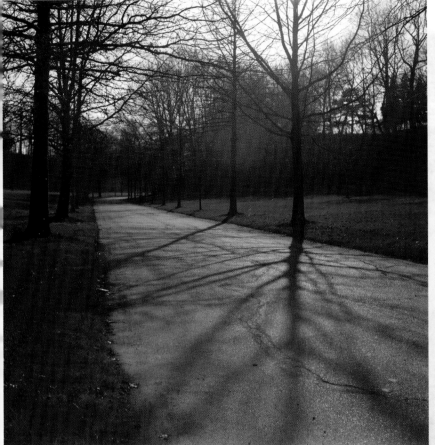

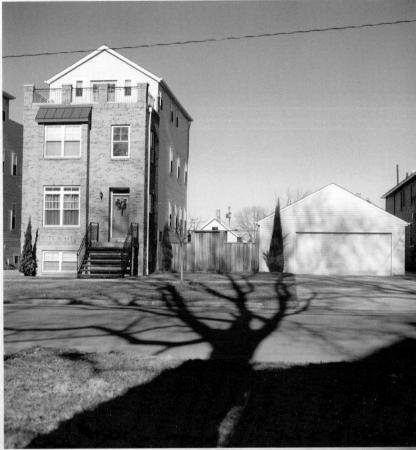

Allée, Riverside Cemetery.

Tree shadow, Tremont. In recent years, the South Side neighborhood has attracted substantial new investment in residential construction, like these three-story townhouses.

Paul Koneazny

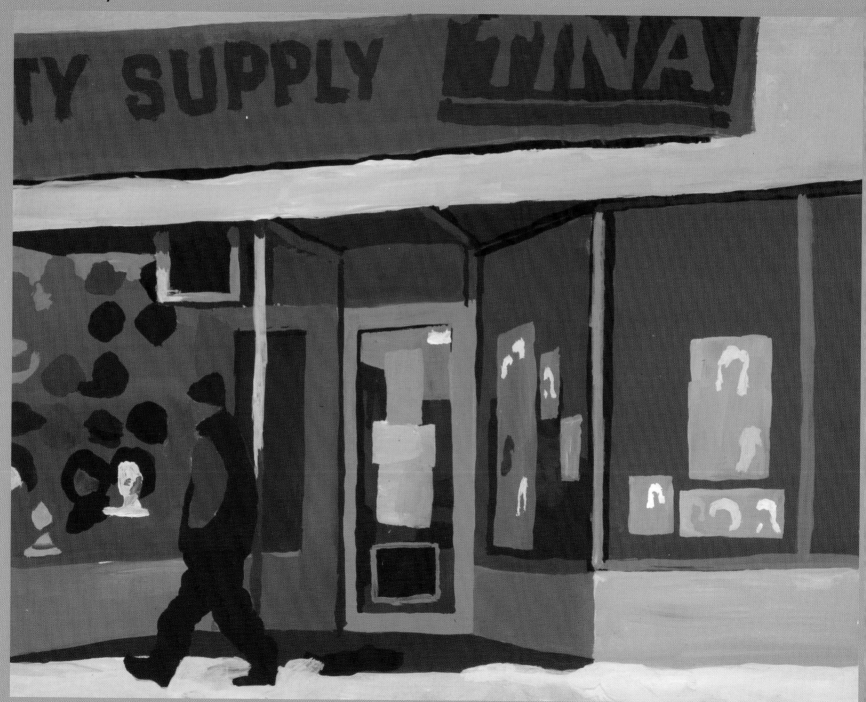

Chris Jungjohann

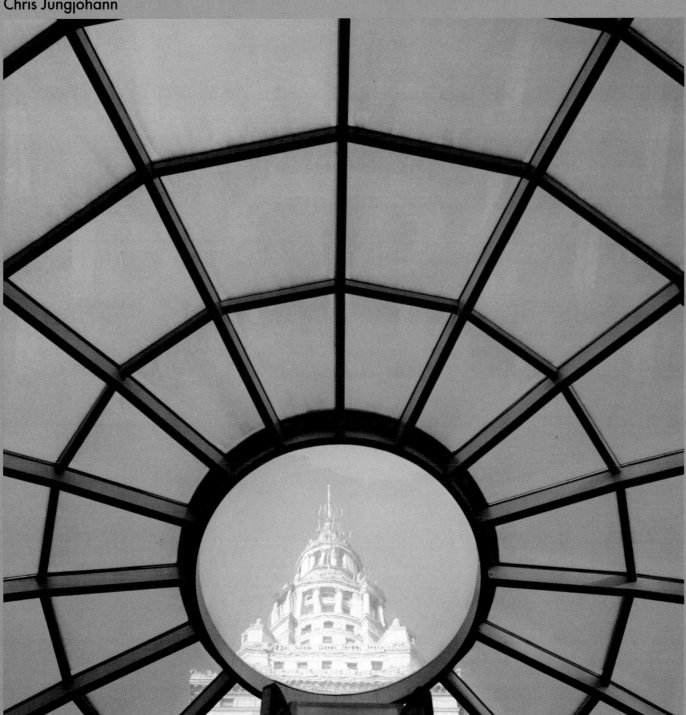

Opposite: Tina's Beauty Supply, 14208 Euclid Avenue, East Cleveland.

Left: A skylight at Tower City Center frames the spire of the Terminal Tower, apex of the railroad and real estate empires assembled by brothers M. J. and O. P. Van Sweringen beginning in 1907.

Peter Reichardt

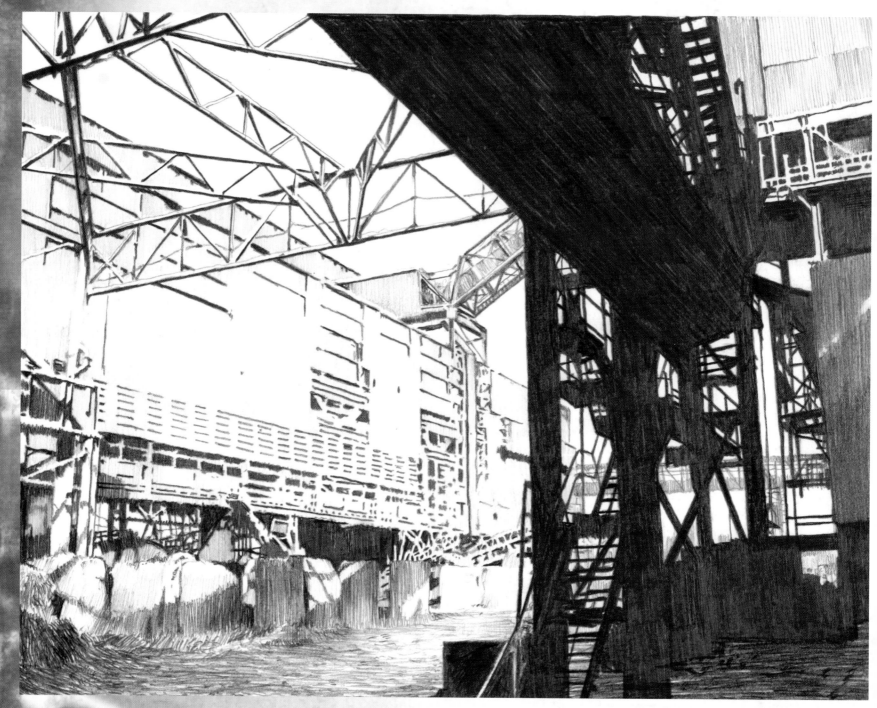

Sarah Laing

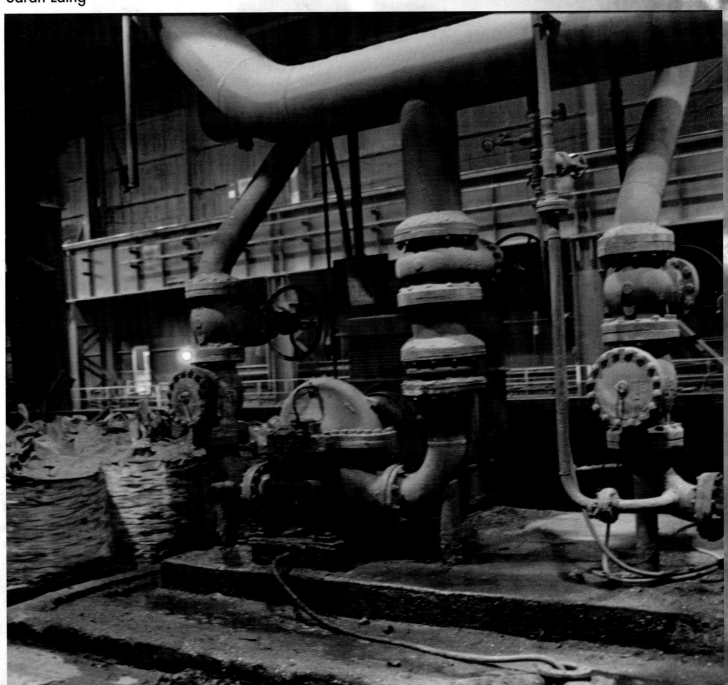

Beauty and power are captured in these scenes at International Steel Group (now Mittal Steel). After 1860, coal, iron, and oil were the elements of the city's prosperity, but much of Cleveland's early industrial heritage has been lost.

Rachel Tag

Mandy Stehouwer

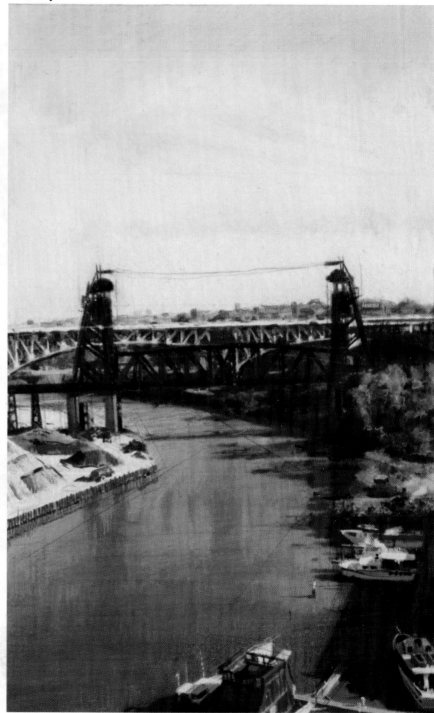

Above: Silhouette, Mill Stream Run Reservation. Cleveland Metroparks comprises a network of reservations and parkways that virtually encircle the city, earning it the nickname "Emerald Necklace."

Right: River scene, looking south from the Lorain-Carnegie Bridge. When oily wastes and debris on the Cuyahoga River caught fire, on June 22, 1969, it captured unwanted national attention but gave momentum to the environmental movement, leading, eventually, to passage of the Clean Water Act.

Lindsey Parker

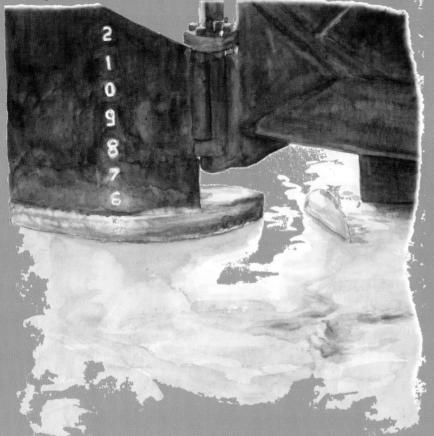

Cecilia Phillips

Nina Barcellona

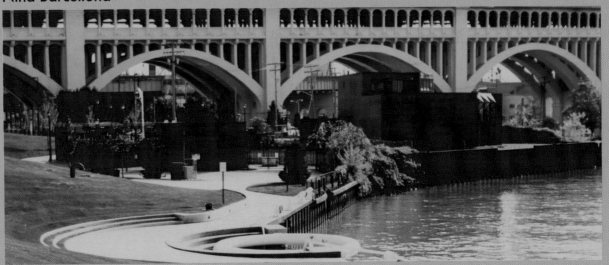

Clockwise from top:
Rudder of the *William G. Mather*, frozen in.

East Side portrait (untitled).

Settlers' Landing, on the east bank of the Cuyahoga River at the foot of Superior Street, is the reputed spot where General Moses Cleaveland and his party of surveyors disembarked on July 22, 1796, to found the city.

Lindsey Parker

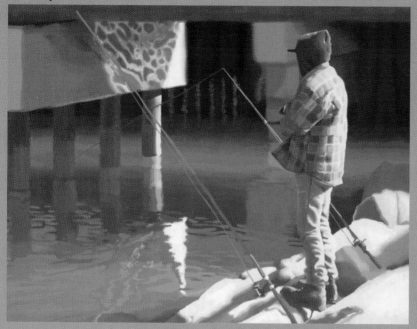

Nina Barcellona

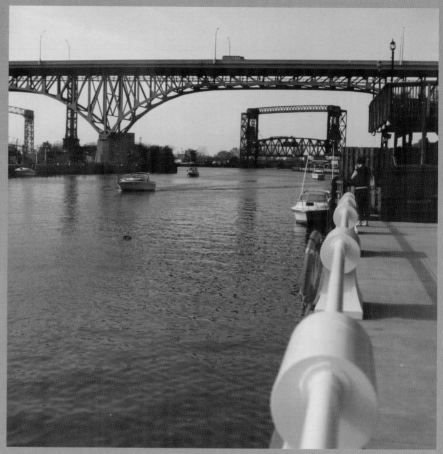

Ben Dewey

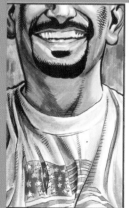
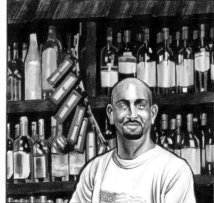

Clockwise from bottom left:
Old Brooklyn portrait: Chad Dakdouk, owner and operator of D's Beverage and Deli.

Winter fishing, underpass near Gordon Park.

River scene: A truss-cantilever span of the Main Avenue Bridge frames the Norfolk Southern Railroad Bridge at the mouth of the Cuyahoga.

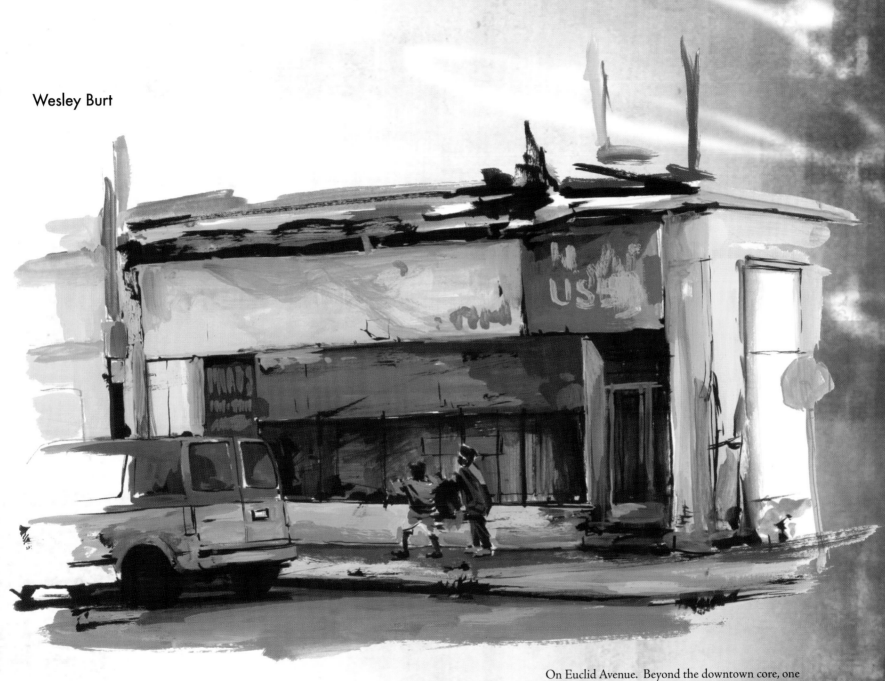

Wesley Burt

On Euclid Avenue. Beyond the downtown core, one writer observed in 1946, "the first miles aren't so good." In 2005, planners looked to the Euclid Corridor project, a reconstruction of the avenue incorporating a new bus rapid-transit service, to foster redevelopment.

Cecelia Phillips

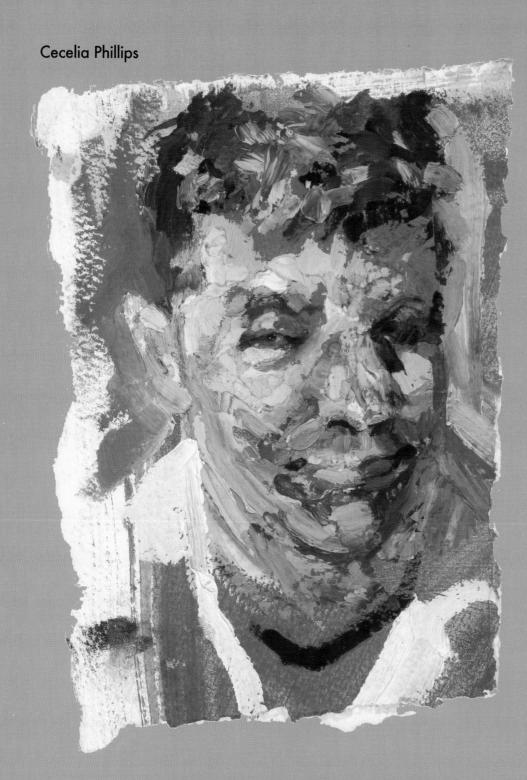

Left: East Side portrait (untitled).

Right: Out of business: the Eagle Supermarket, Euclid Avenue.

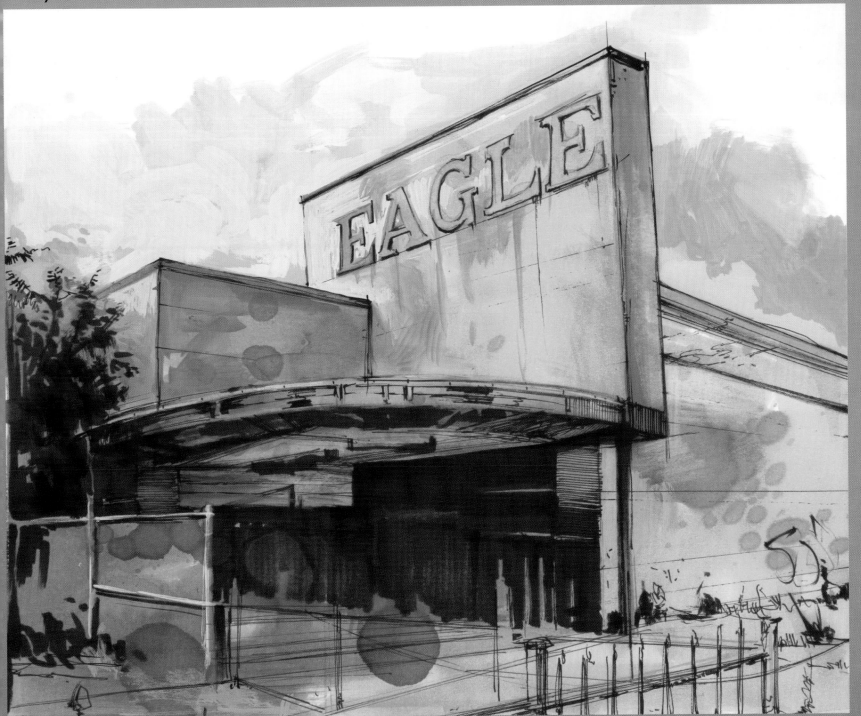

Lindsey Alberding

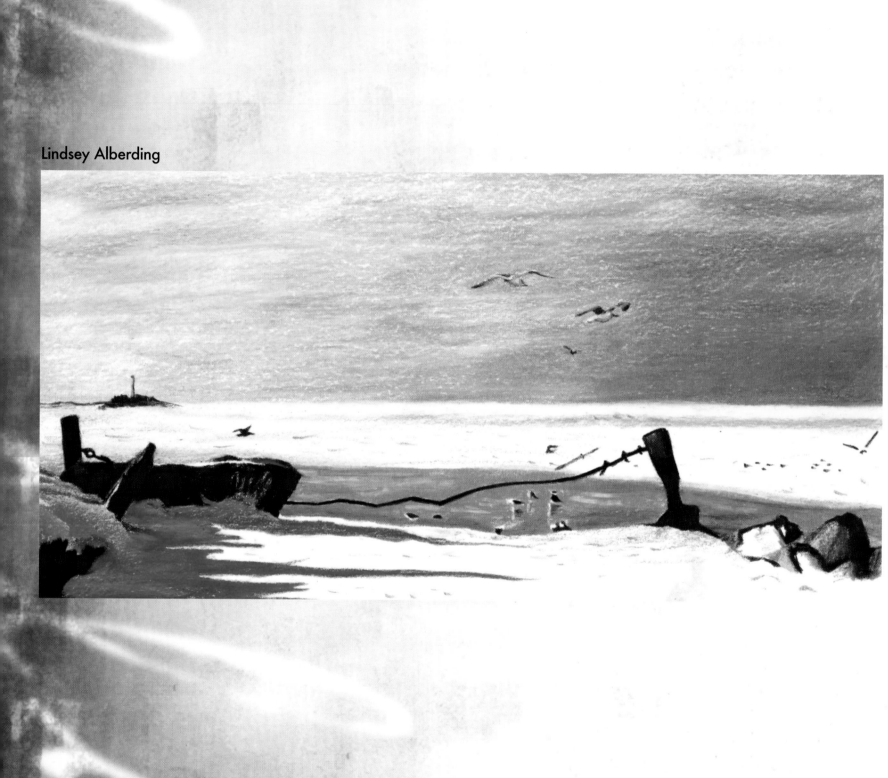

Cecelia Phillips

Opposite: Iced in at Gordon Park.

Left: East Side portrait (untitled).

Wesley Burt

Nina Barcellona

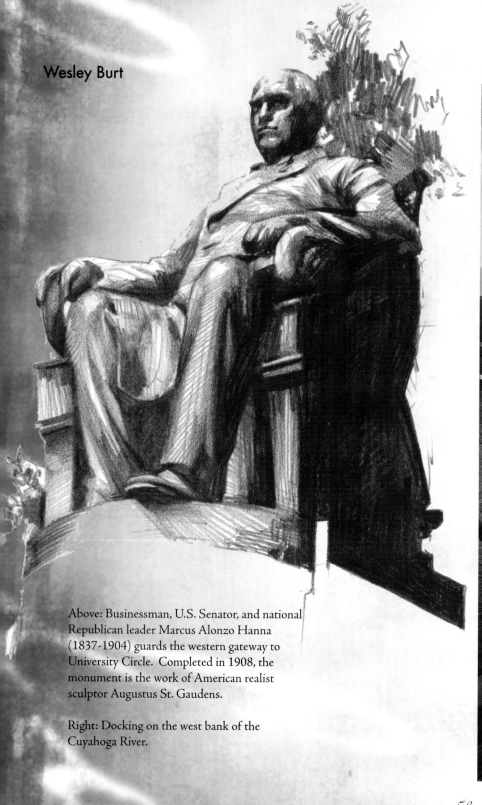

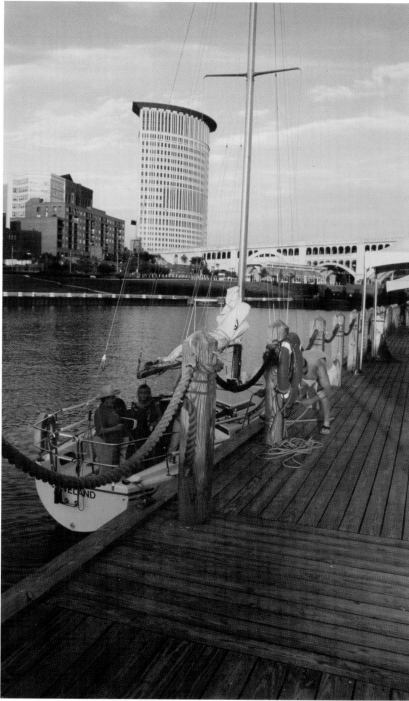

Above: Businessman, U.S. Senator, and national
Republican leader Marcus Alonzo Hanna
(1837-1904) guards the western gateway to
University Circle. Completed in 1908, the
monument is the work of American realist
sculptor Augustus St. Gaudens.

Right: Docking on the west bank of the
Cuyahoga River.

Salvatore Schiciano

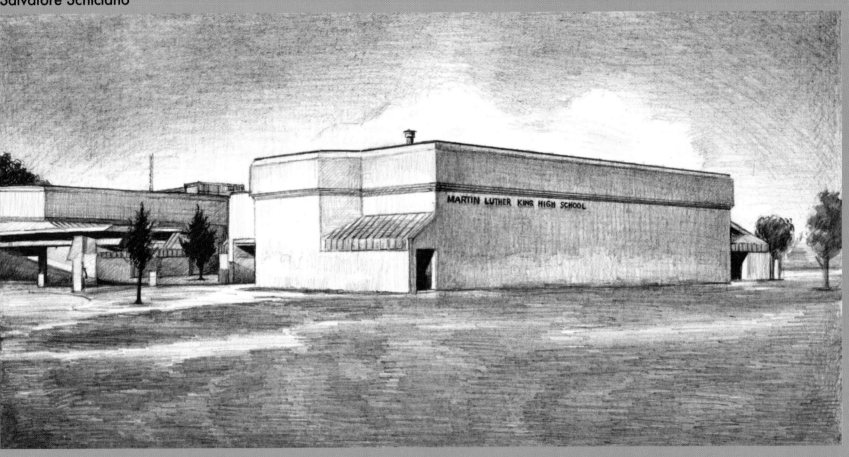

Martin Luther King Jr. High School, East 71st Street, Hough. Once the pride of the city, the Cleveland public schools have struggled with declining enrollment, inadequate revenue, fractious politics, and mismanagement. Withal, many teachers and administrators rise above the district's challenges to educate the city's children.

Christi Birchfield

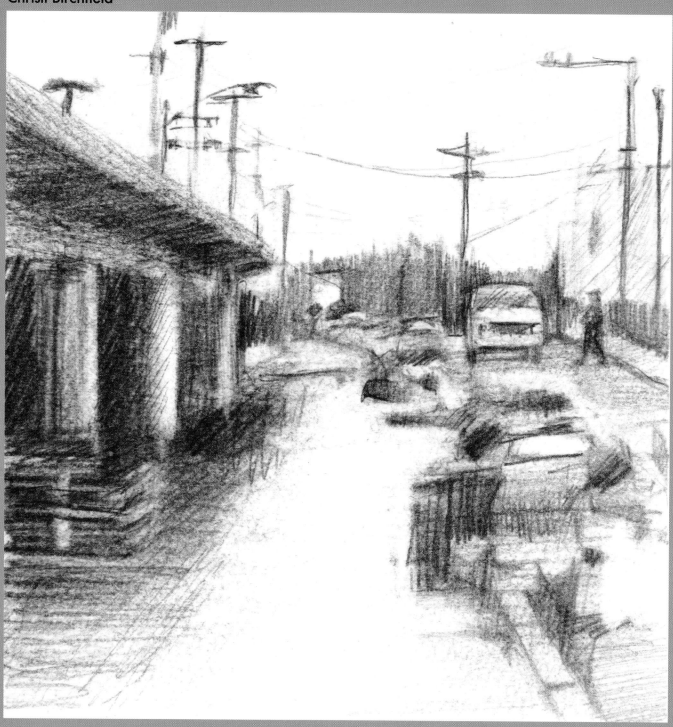

Mary Savage

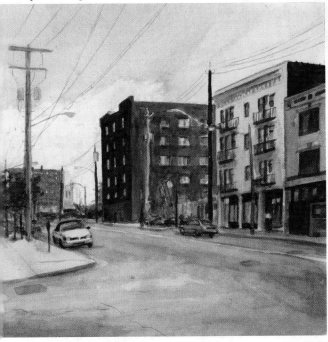

Drew Hood

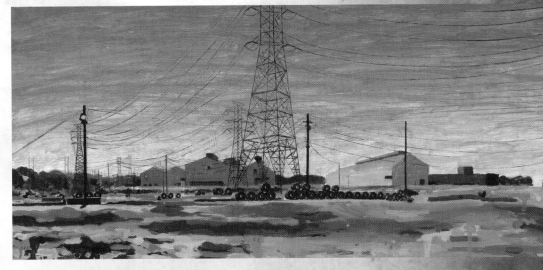

Mandy Stehouwer

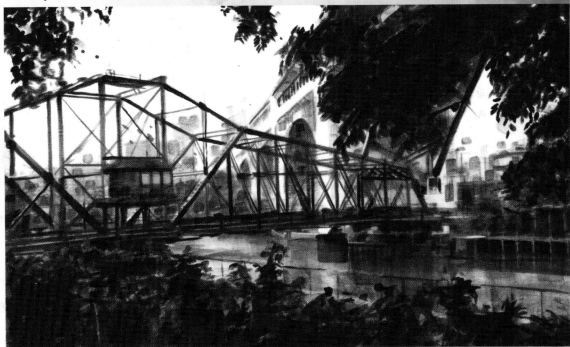

Left: Behind the West Side Market.

Clockwise from top left:
Euclid Avenue and East 117th Street.

Coils of flat-rolled steel lie in the yard of a
West Side mill.

Hearing one long and two short blasts of
the horn, the tender of the Center Street
Swing Bridge (1901) sets the span in
motion to accommodate an approaching
boat.

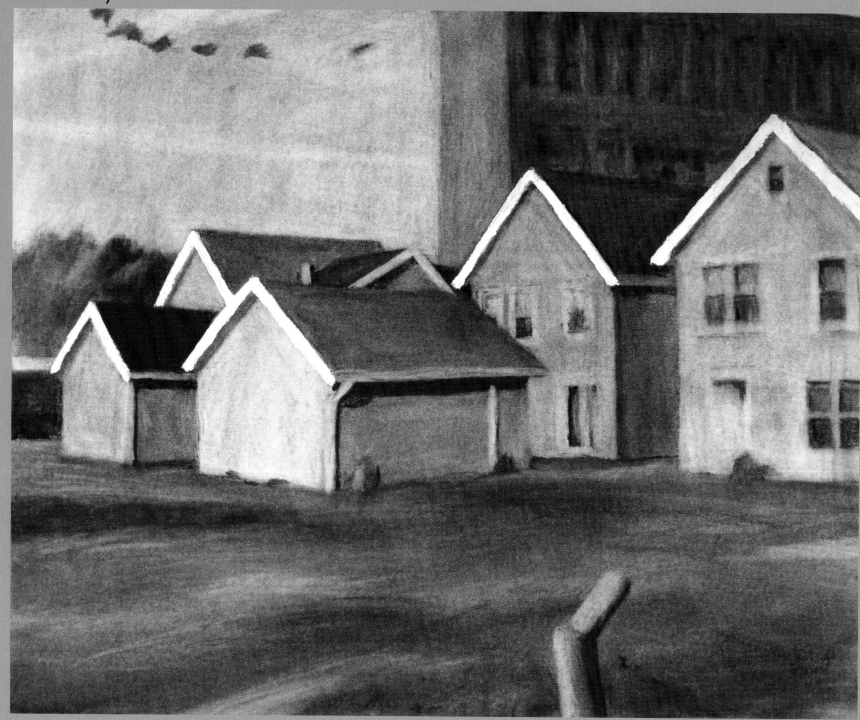

Chris Jungjohann

Left: In Hough. The neighborhood takes its name from Hough Avenue, a principal street, named for early landowners Oliver and Eliza Hough. Once a predominantly white and middle-class neighborhood, Hough underwent rapid social and racial change in the 1950s, leading, eventually, to the devastating Hough Riots of July 1966. In recent years the neighborhood has seen substantial rebuilding.

Right: The futuristic appendage belongs to the Rock and Roll Hall of Fame and Museum, opened in 1995.

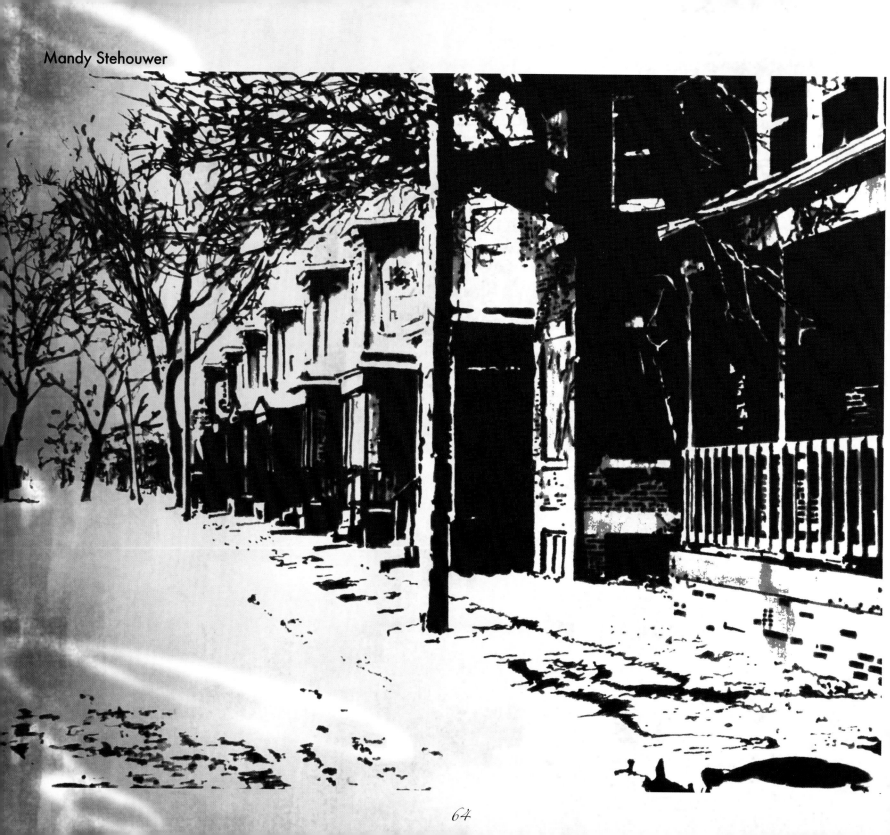

Mandy Stehouwer

Mary Savage

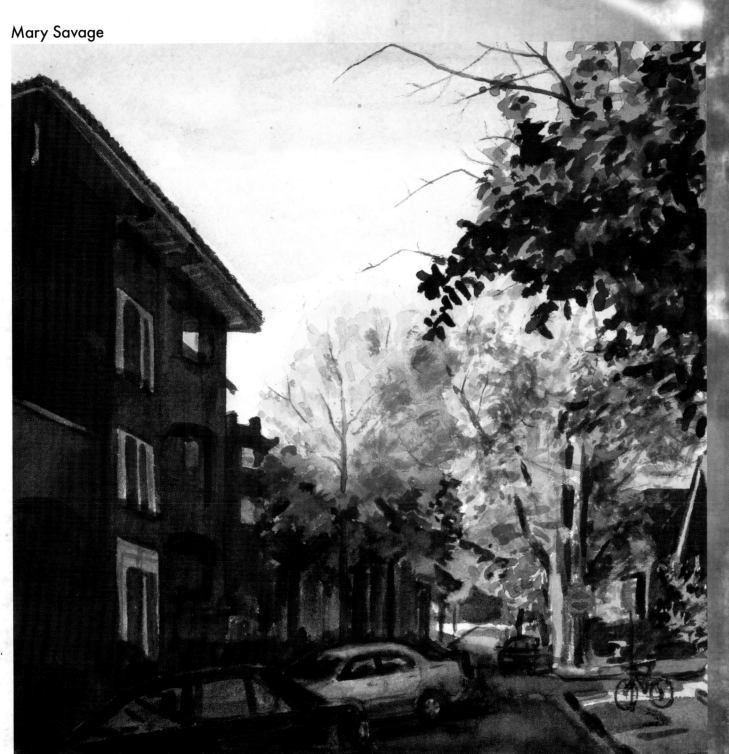

Left: Terrace apartments on Keemar Court, now abandoned, have a rhythmic beauty.

Right: Adjacent to the Case campus, Hessler Road is prized for its distinctive architecture and wood-block pavement. The annual Hessler Street Fair retains the ambiance of the 1960s counterculture that originated it.

Drew Hood

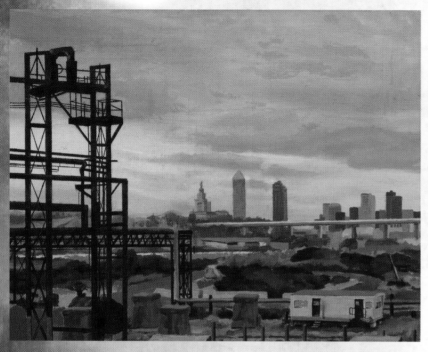

Sarah Laing

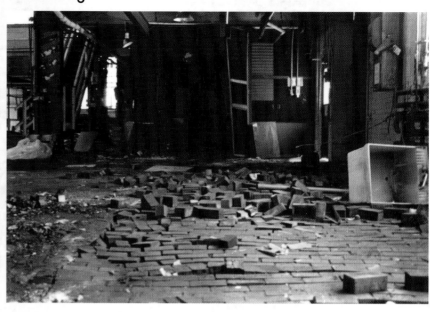

Wesley Burt

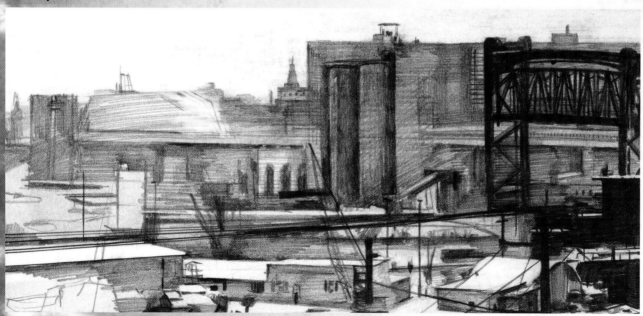

Clockwise from bottom left:
From the windows at Tower City Center unfolds an expansive panorama of industry and engineering.

View from the West Side works of International Steel Group (now Mittal Steel).

An abandoned factory contains the volcanic eruption of its wood-block floor.

Right: A street musician improvises outside the Palace Theatre at Playhouse Square.

Andrew Zimbelman

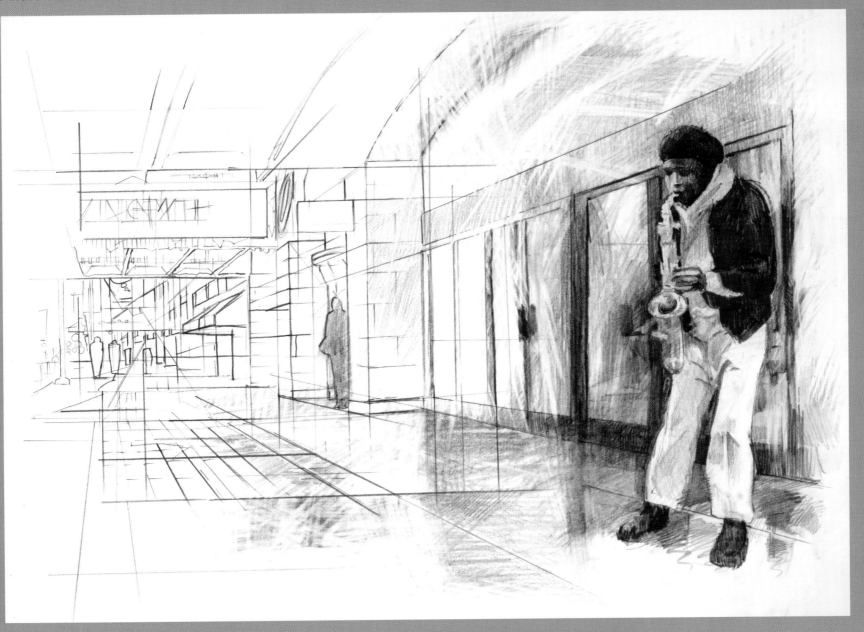

Lindsey Alberding

Albert Beltz

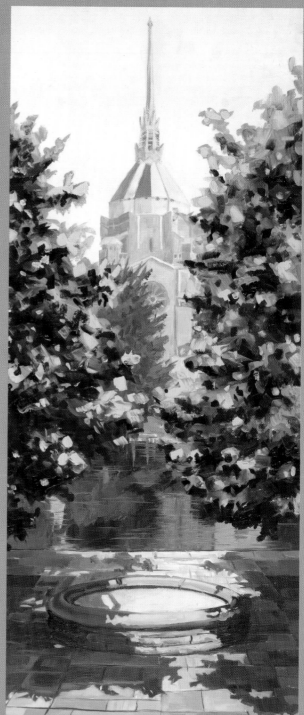

Above: Clutterboxe Antiques on Lorain Avenue, "Antiques Row."

Right: The Modernistic-Gothic Epworth-Euclid United Methodist Church (1928), viewed from the Fine Arts Garden of the Cleveland Museum of Art, is one of the city's most elegant vistas.

Opposite: On West 25th Street in Ohio City.

Christi Birchfield

Peter Reichardt

Albert Beltz

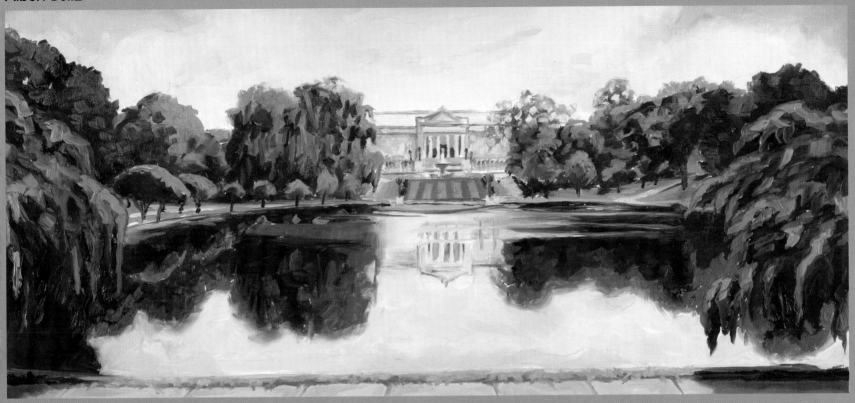

Wesley Burt

Opposite:
On April 14, 1994, President Bill Clinton threw out the first ball to inaugurate Jacobs Field as the new home of the Cleveland Indians.

Above: Opened in 1916, the Cleveland Museum of Art was housed in a neoclassic temple framed by the elegantly landscaped Fine Arts Garden. The local art historian Walter C. Leedy has called this "Cleveland's million-dollar view."

Left: Riding the Red Line.

Chris Jungjohann

Murray Hill Road, Little Italy. Between 1900 and 1920,
Cleveland's Italian-born population grew more than sixfold,
from three thousand to nineteen thousand. Many settled in the
area of Murray Hill and Mayfield roads. Although the Italian-
American community has decentralized, the neighborhood
retains its ethnic identity and traditions.

Cecelia Phillips

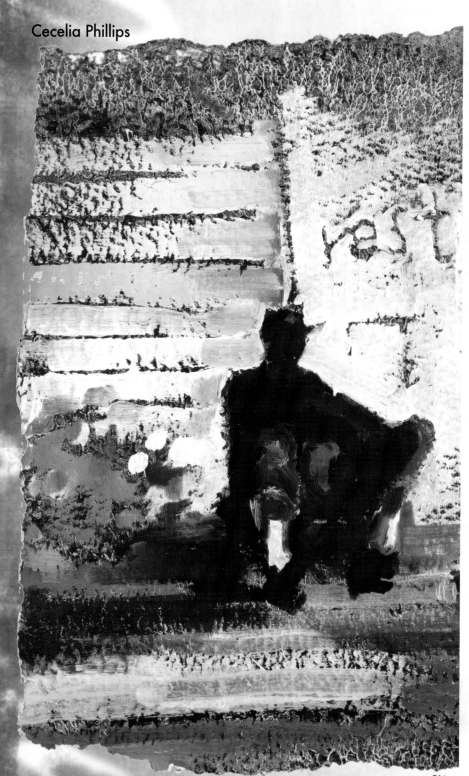

Dana Hardy

Above: Nighttime view of The
Q and The Jake—Quicken Loans
Arena and Jacobs Field.

Left: East Side portrait (untitled).

74

Salvatore Schiciano

Dana Hardy

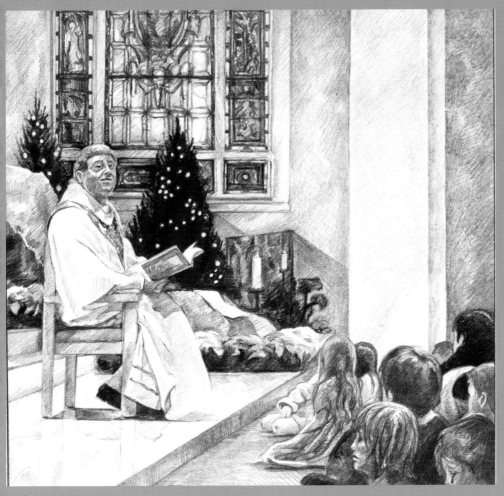

Above: Father Philip Racco speaks to the children, Holy Rosary Church, Little Italy.

Right: The city built a new football stadium after Browns owner Art Modell shocked Clevelanders by moving the storied franchise to Baltimore. Cleveland got a new N.F.L. team and kept the old name and colors.

Salvatore Schiciano

Paul Koneazny

Salvatore Schiciano

Clockwise from left:
Sunset, East Boulevard.

Since the 1920s, suburbs "content in
their municipal independence and the
charm of their residential sections"
(William Ganson Rose, *Cleveland: The
Making of a City*) have strangled the
mother city, siphoning off tax income
and talent.

Off Euclid Avenue.

Christi Birchfield

Peter Reichardt

Cecelia Phillips

Clockwise from left:
Off St. Clair Avenue.

West 25th and Lorain, the
commercial hub of Ohio City.

At International Steel Group (now
Mittal Steel).

Mandy Stehouwer

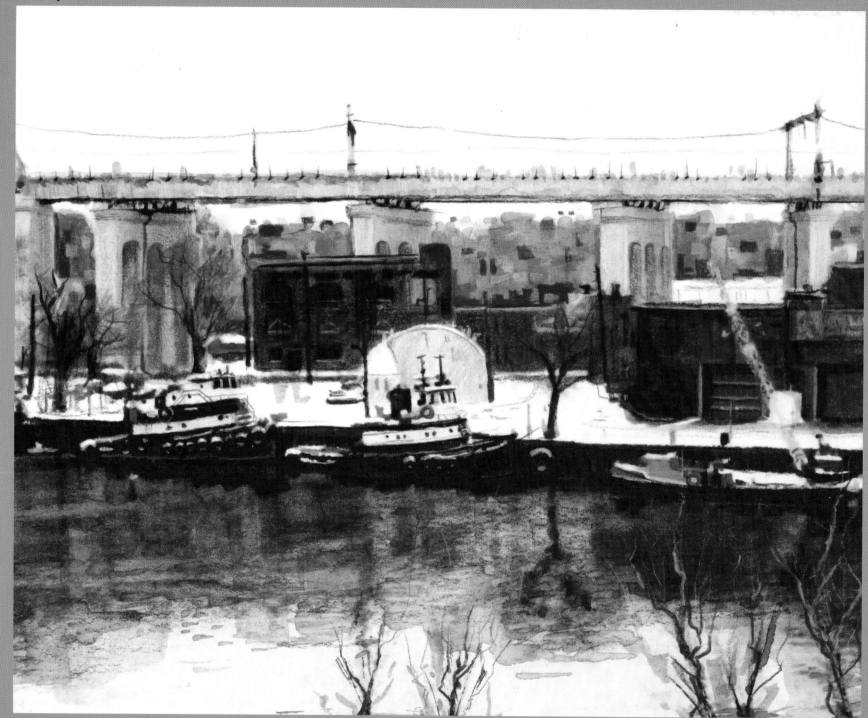

Cecelia Phillips

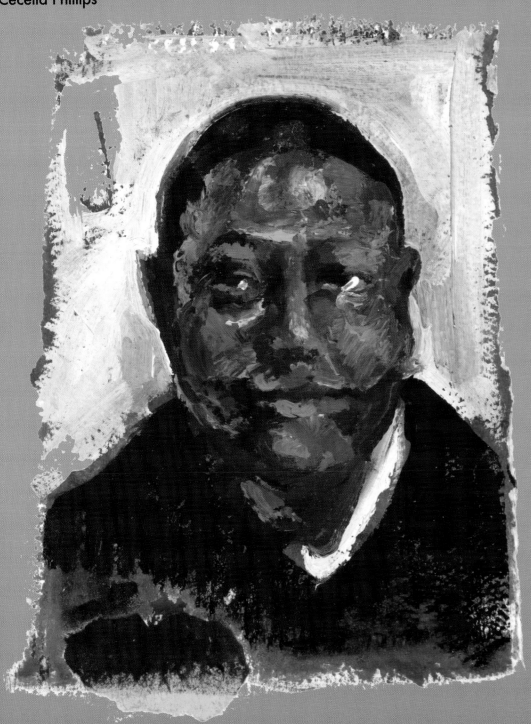

Opposite: The view from Carter Road in the Flats.

Left: East Side portrait (untitled). Cleveland is a multi-ethnic city. Fifty-one percent of its 478,403 people are African-American, according to the U.S. Census of 2000, which also reported 25,385 Puerto Ricans, 2,973 Mexicans, 2,083 Chinese, 1,145 Asian Indians, and 1,054 Vietnamese living here.

Rachel Nottingham

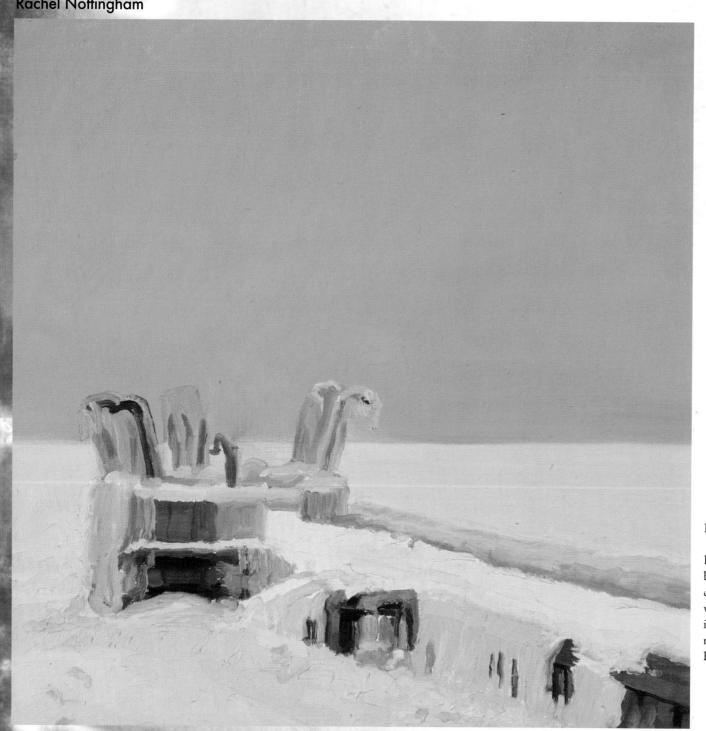

Left: Winter scene, Bratenahl.

Right: East Ninth Street became the heart of the downtown financial district when the area was cleared in the 1960s and gradually redeveloped as part of the Erieview urban renewal plan.

Andrew Zimbelman

Drew Hood

Mary Savage

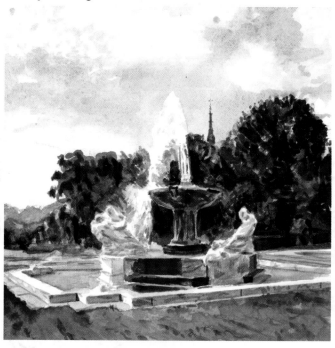

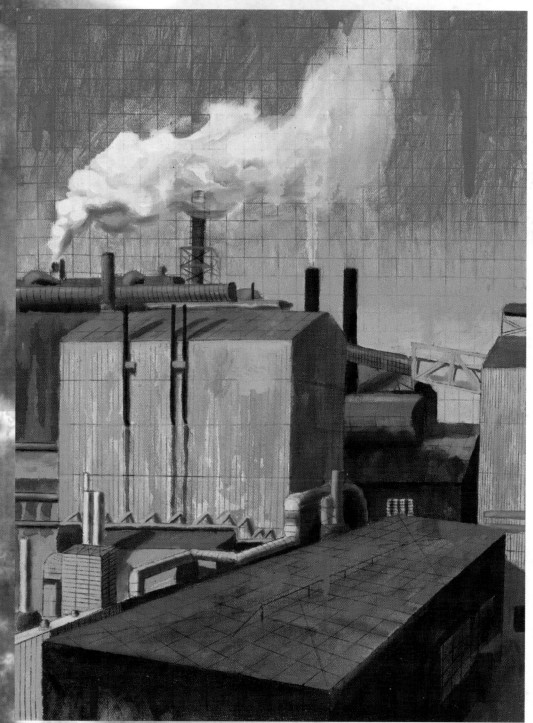

Left: Making steel.

Above: *Fountain of the Waters* (Chester A. Beach, 1928), in the Fine Arts Garden, Cleveland Museum of Art.

Opposite, clockwise from top left: On Kirkham Avenue, Slavic Village. Slavic Village encompasses what was historically the largely Czech Karlin neighborhood and Warszawa, Cleveland's largest Polish colony.

In the rainforest of the Cleveland Botanical Garden.

The view from West Sixth and St. Clair.

Christi Birchfield

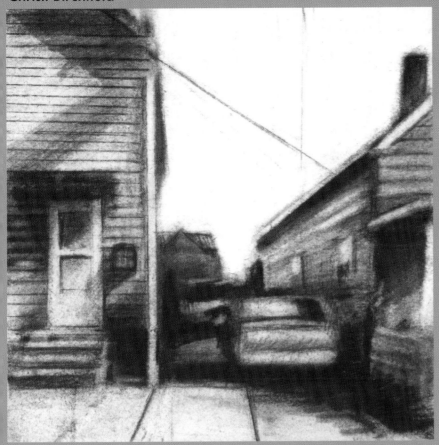

Albert Beltz

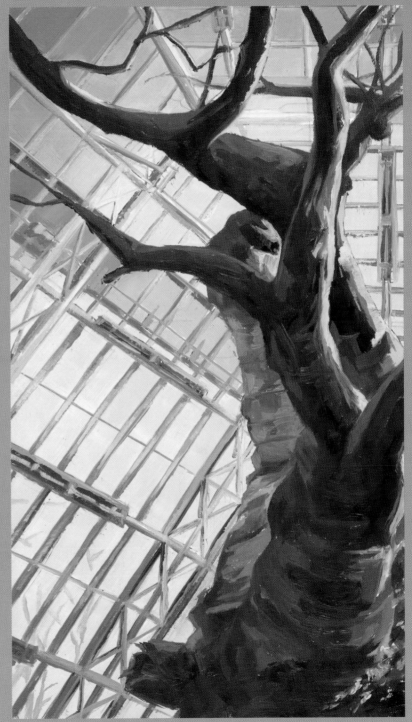

Dana Hardy

Nina Barcellona

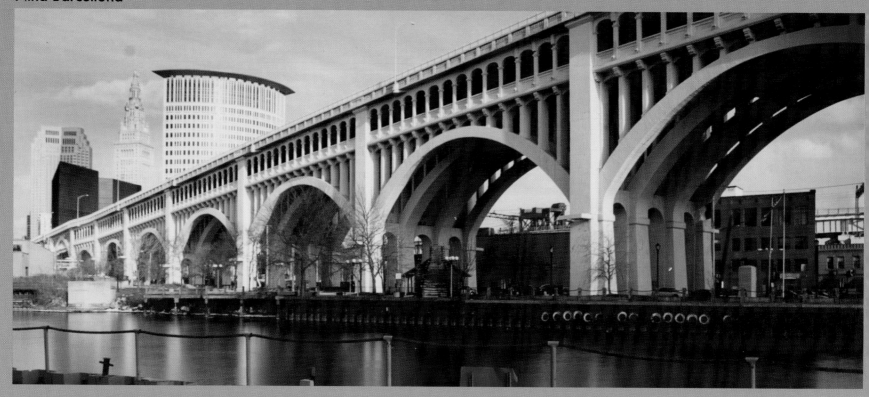

Abby Feldman

Above: Since the completion of the Detroit-Superior High-Level Bridge in 1917, generations of artists and photographers have captured this sweeping view from the west bank of the river.

Left: The parabolic arches of the Lorain Road Bridge sweep across the Rocky River Reservation of Cleveland Metroparks. The American Institute of Steel Construction judged it the most beautiful steel bridge in its class erected in 1935.

Opposite: High on the list of Cleveland's treasures are the Cleveland Museum of Art (here looking into the rotunda and gallery beyond) and the West Side Market (inside the main hall).

Albert Beltz

Christi Birchfield

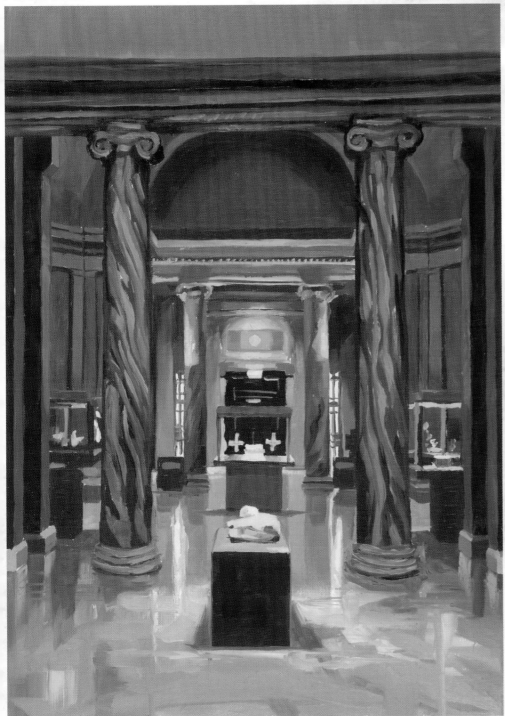

Paul Koneazny

Andrew Zimbelman

Left: A city lot near Cleveland Browns Stadium.

Right: Intermission at the Palace Theatre.

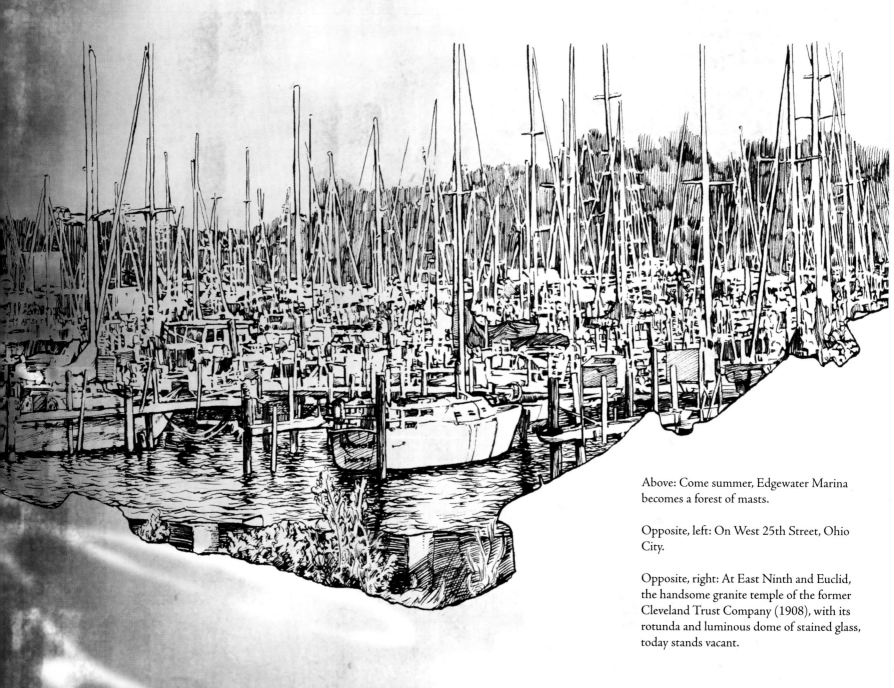

Lindsey Parker

Above: Come summer, Edgewater Marina becomes a forest of masts.

Opposite, left: On West 25th Street, Ohio City.

Opposite, right: At East Ninth and Euclid, the handsome granite temple of the former Cleveland Trust Company (1908), with its rotunda and luminous dome of stained glass, today stands vacant.

Christi Birchfield

Andrew Zimbelman

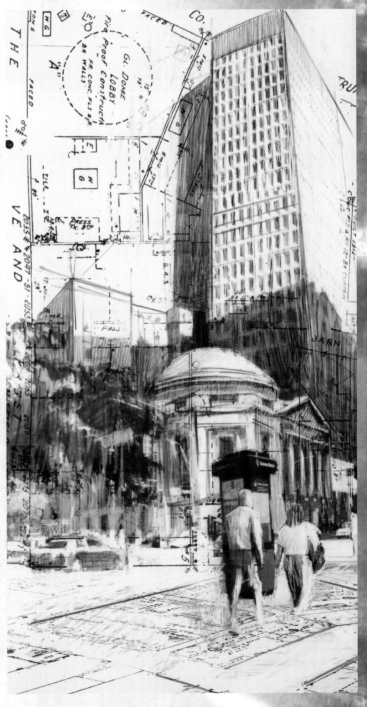

89

Wesley Burt

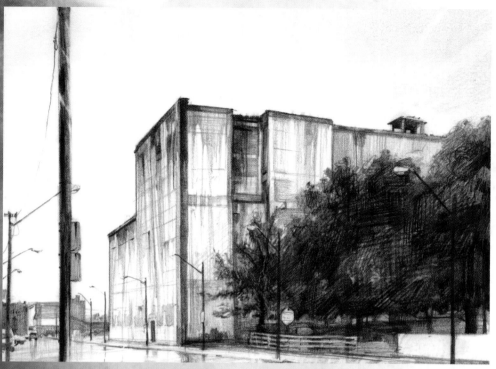

Cecelia Phillips

Ben Dewey

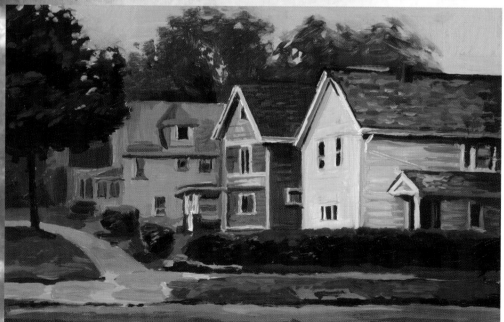

Clockwise from bottom left:
In Old Brooklyn.

The vacant Euclid Sportswear Company, on Euclid Avenue, stands as a reminder of Cleveland's onetime prominence in the garment industry. In 1921, garment manufacturers here employed more than five thousand men and women.

East Side portrait (untitled).

Paul Koneazny

Christi Birchfield

Peter Reichardt

Clockwise from bottom left:
Atop a blast furnace, since destroyed.

On Euclid Avenue.

On Broadway in Slavic Village.

91

Sarah Laing

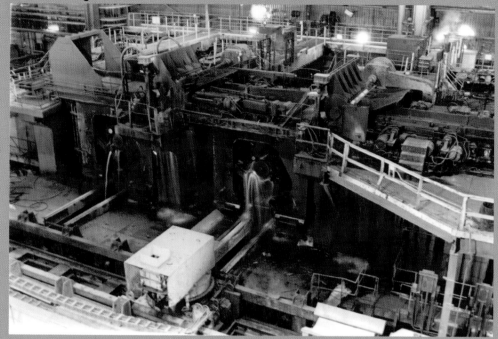

Ben Dewey

Lindsay Parker

Christi Birchfield

Rachel Nottingham

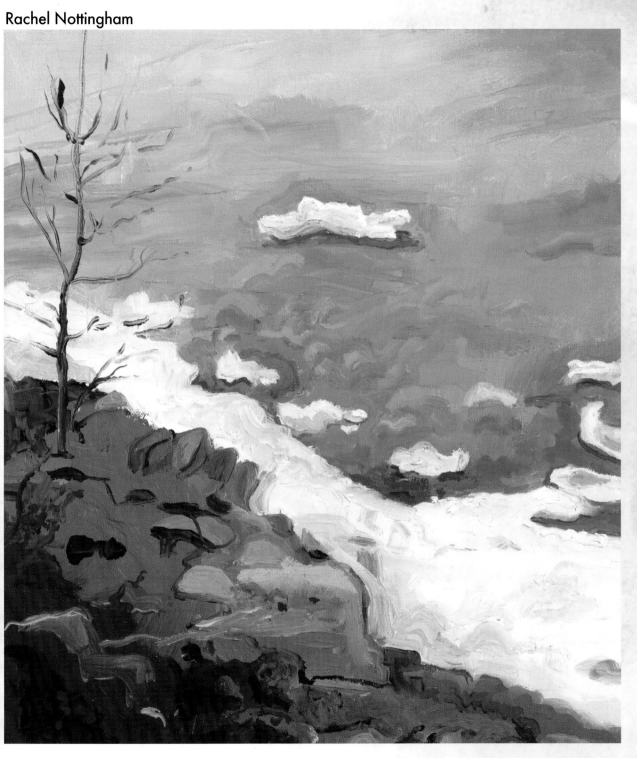

Opposite, clockwise from top left:
At International Steel Group (now
Mittal Steel).

Old Brooklyn portrait: Jack
Amburgey, business developer and
entrepreneur.

On Fleet Avenue in Slavic Village.

Aerial view, winter.

Left: Winter eases its grip.

Mary Savage

Left: The Blue and Green Lines of the Regional Transit Authority merge on the east side of Shaker Square, near the landmark Moreland Courts Condominiums.

Right: On East 105th Street in Glenville.

Cecelia Phillips

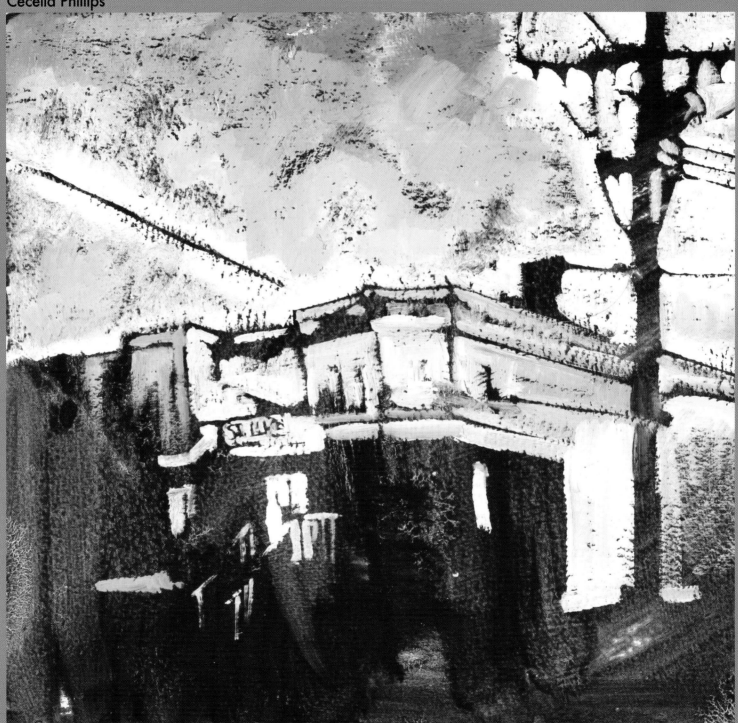

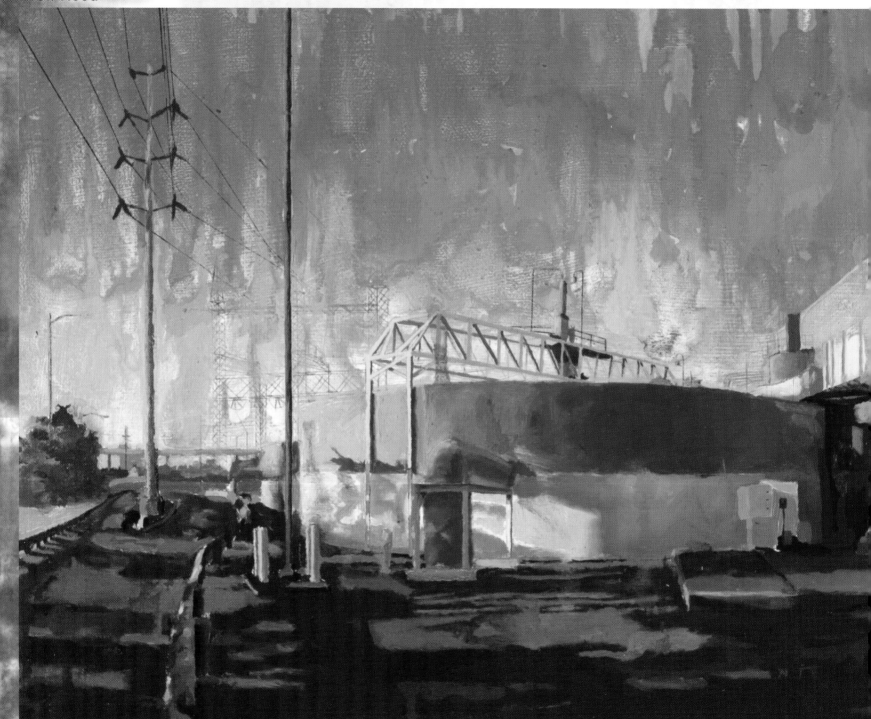

Dana Hardy

Cecelia Phillips

Left: Water treatment plant,
International Steel Group (now
Mittal Steel).

Above: On Lakeside Avenue
downtown, looking east from the
Warehouse District.

Right: League Park, Hough.

Sarah Laing

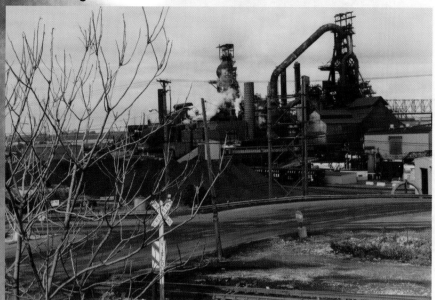

Rachel Nottingham

Abby Feldman

Clockwise from bottom left:
All-purpose trail, North Chagrin
Reservation.

Blast furnaces, International Steel
Group (now Mittal Steel).

Lake Erie under a brooding sky.

Mandy Stehouwer

Lindsey Alberding

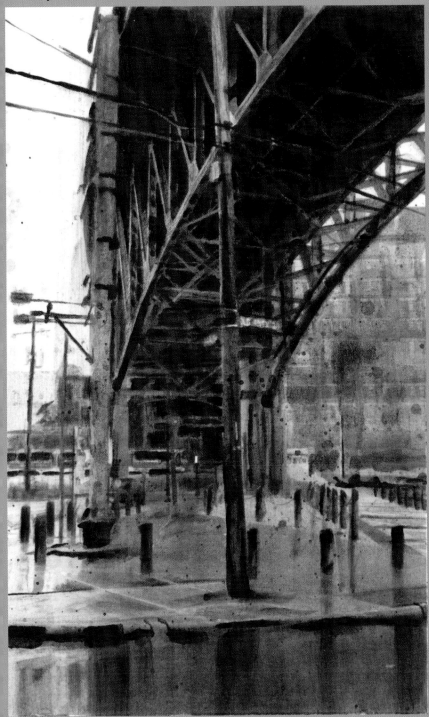

Left: A rainy day in the Flats.

Above: The Treehouse, Tremont.

Mary Savage

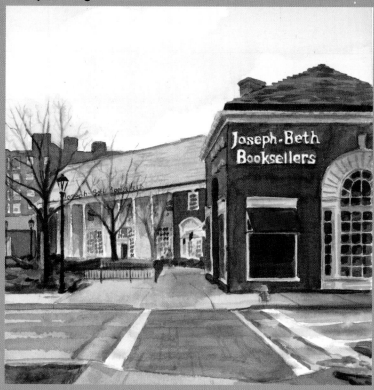

Mandy Stehouwer

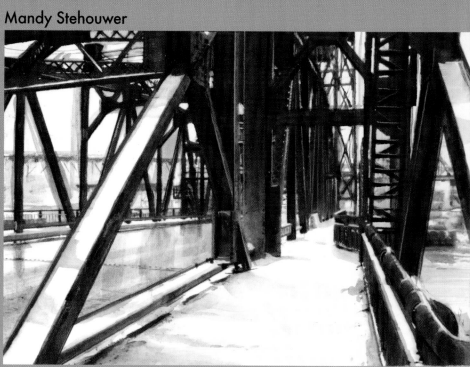

Christi Birchfield

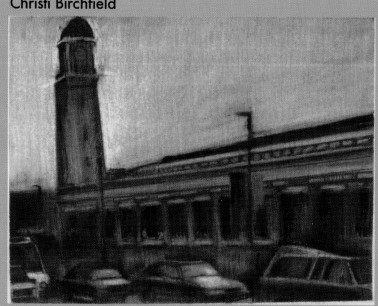

Albert Beltz

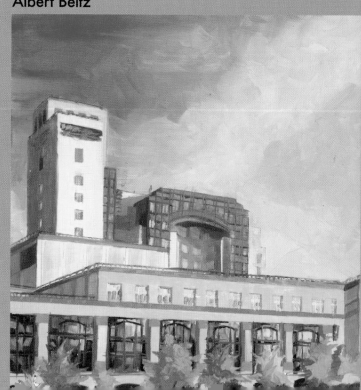

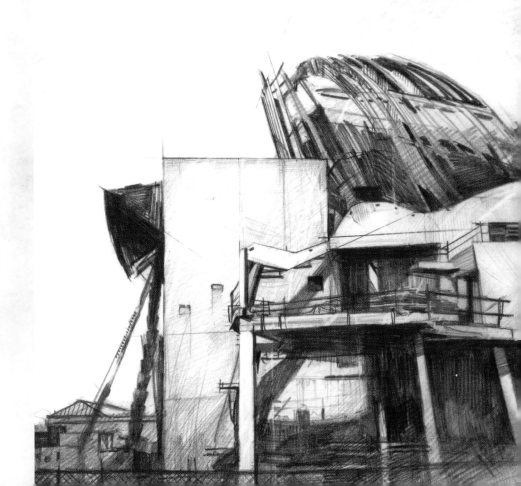

Wesley Burt

Opposite, clockwise from top left:
Joseph-Beth Booksellers was, briefly, a bright spot on Shaker Square, where it filled the old Stouffer's Restaurant space. It has since moved to a more up-market suburban location.

On the West Third Street Bridge, near Tremont.

University Hospitals of Cleveland, Euclid Avenue. The ever-expanding facilities of UH, together with those of the Cleveland Clinic, have made Cleveland a national center for medical education, research, and treatment.

With its clock and water tower, the West Side Market is a sentinel at the busy crossroads of West 25th and Lorain.

Right: The Peter B. Lewis Building takes form on the Case campus.

Andrew Zimbelman

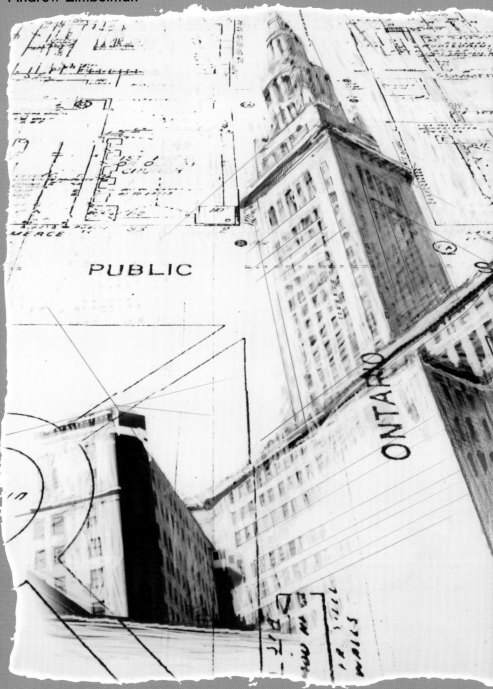

Left: Winter sky.

Right: A railroad station built by the New York Central provided the foundation for the Van Sweringen brothers' ambitious commercial development using the air rights above. The Cleveland Union Terminal complex encompassed office buildings (including the fifty-two-story Terminal Tower), a hotel, a department store, a central post office, stores, and restaurants.

Drew Hood

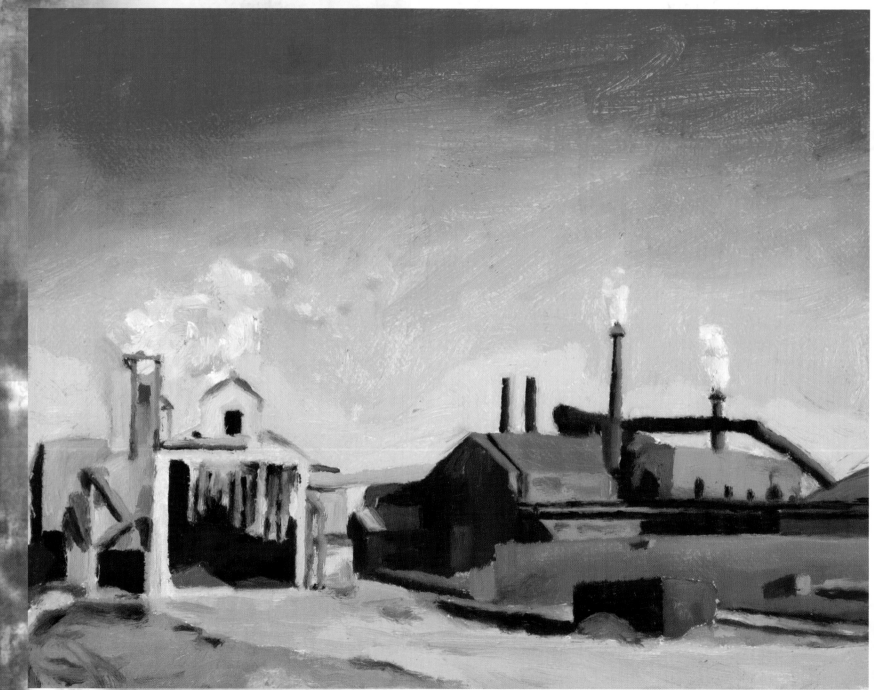

Wesley Burt

Ben Dewey

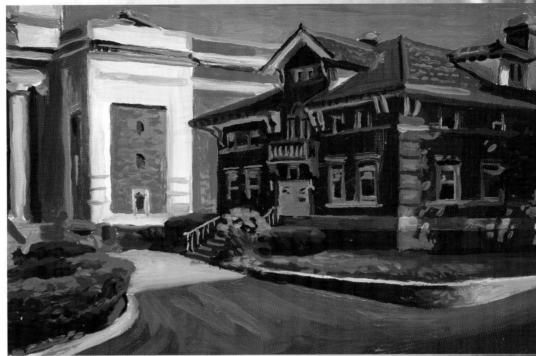

Nina Barcellona

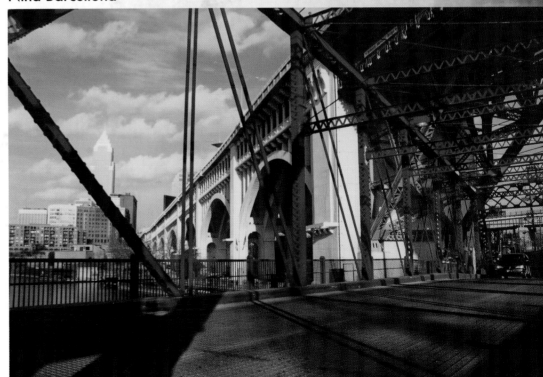

Opposite: The scene is 2004—or is it 1904? The iron and steel industry has been a vital part of the city's identity since the mid-nineteenth century.

Clockwise from top left:
A view of the West Side, from Tower City Center.

Our Lady of Good Counsel, Pearl Road, Old Brooklyn.

The view from the deck of the Center Street Swing Bridge.

Paul Koneazny

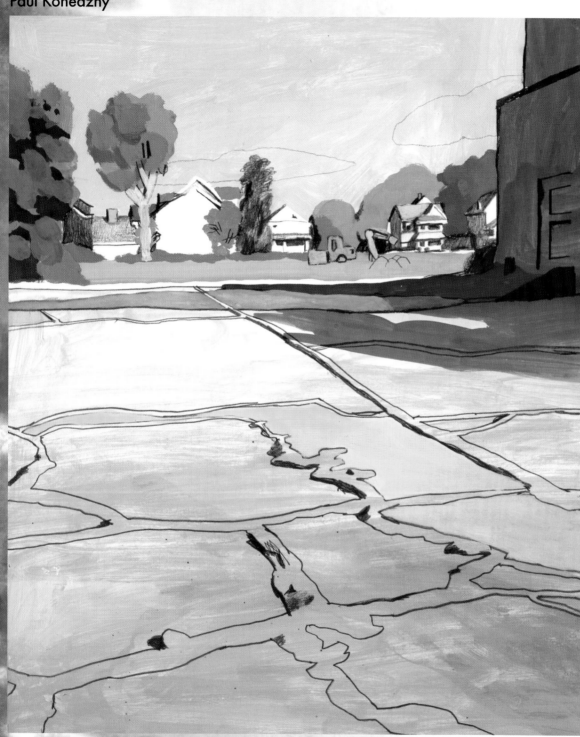

Schoolyard, Hough.

Sarah Laing

Rachel Nottingham

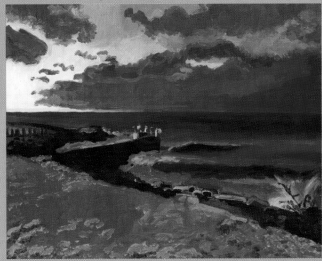

Mandy Stehouwer

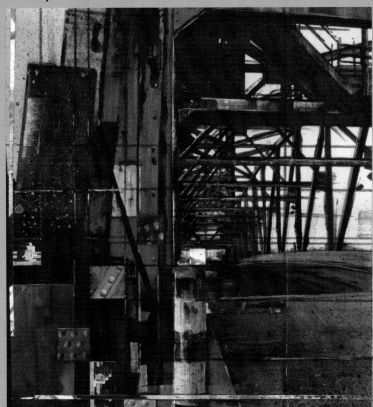

Clockwise from top left:
It's 24/7 at International Steel
Group (now Mittal Steel).

Late day at Newport Harbor,
Bratenahl.

The West Third Street Bridge.

Rachel Nottingham

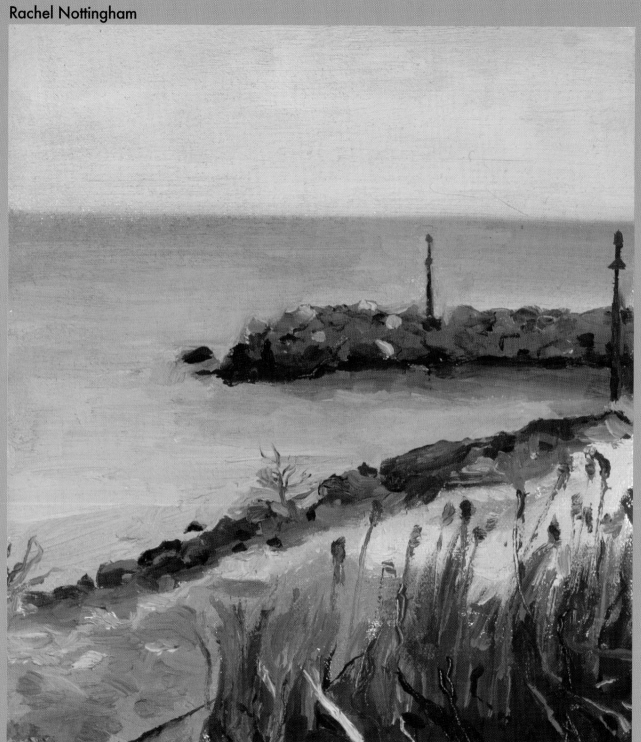

Left: Lake Erie in repose, Newport Harbor, Bratenahl.

Opposite, clockwise from top left: At Edgewater Park.

On Euclid Avenue.

On East 115th Street, off Euclid Avenue.

Abbey Market, Abbey Avenue at West 20th Street, in an area known as Duck Island.

Abby Feldman

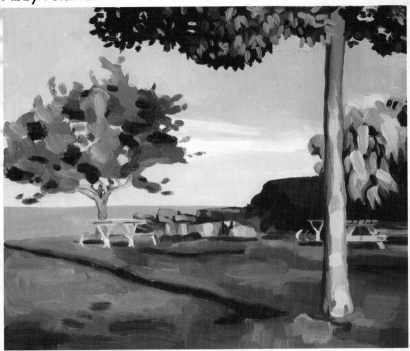

Mary Savage

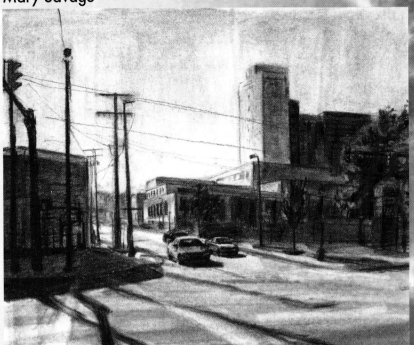

Lindsey Alberding

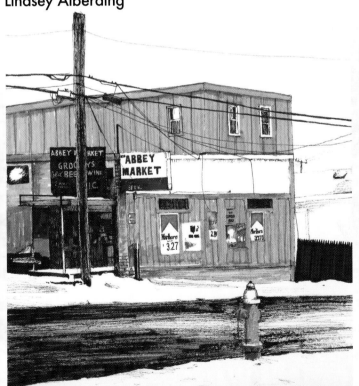

Mary Savage

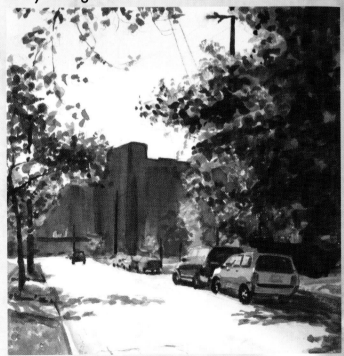

109

Albert Beltz

Ben Dewey

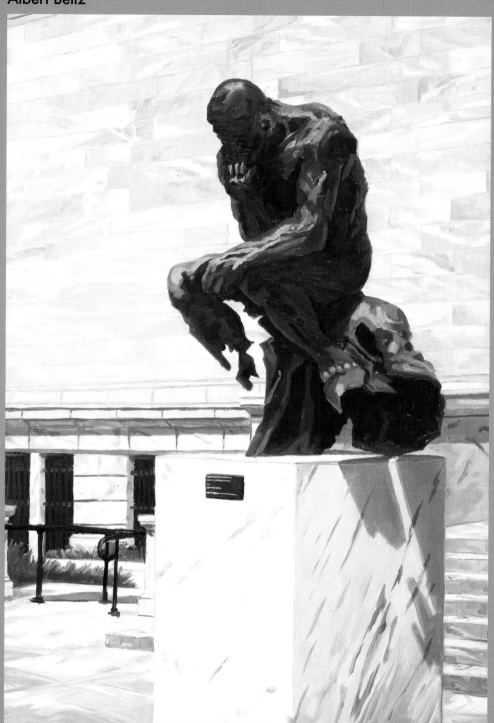

Left: August Rodin's *The Thinker* (1917) graces the entrance to the Cleveland Museum of Art. Irreparably damaged by a pipe bomb in 1970, the sculpture speaks to the intersection of art and politics.

Above: Old Brooklyn portrait: Gloria Janos, local historian and executive director of Archwood-Denison Concerned Citizens.

Opposite: HealthSpace Cleveland (formerly the Cleveland Health Museum), located on Euclid Avenue, has provided health education since 1940 and was the first museum of its kind in the United States. Next door is the Henry Windsor White Mansion (1901), one of only a handful of grand houses from the avenue's heyday that have survived.

Wesley Burt

Andrew Zimbelman

Left: First Presbyterian (Old Stone) Church grew from a Sunday school established in 1820. It has steadfastly remained in its building on Public Square even as its members migrated outward.

Opposite, clockwise from top left: The view from the private Shoreby Club, Bratenahl.

At International Steel Group (now Mittal Steel).

East Side portrait (untitled).

Rooftops, East 60th and St. Clair.

Rachel Nottingham

Peter Reichardt

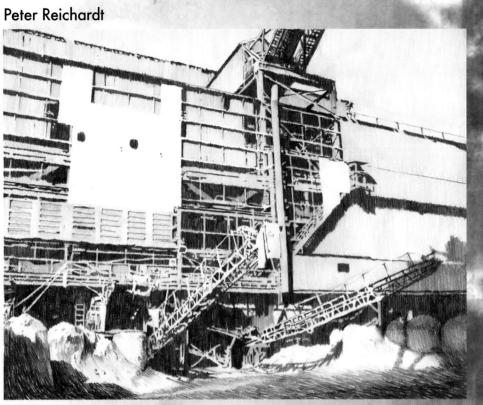

Paul Koneazny

Cecelia Phillips

Mandy Stehouwer

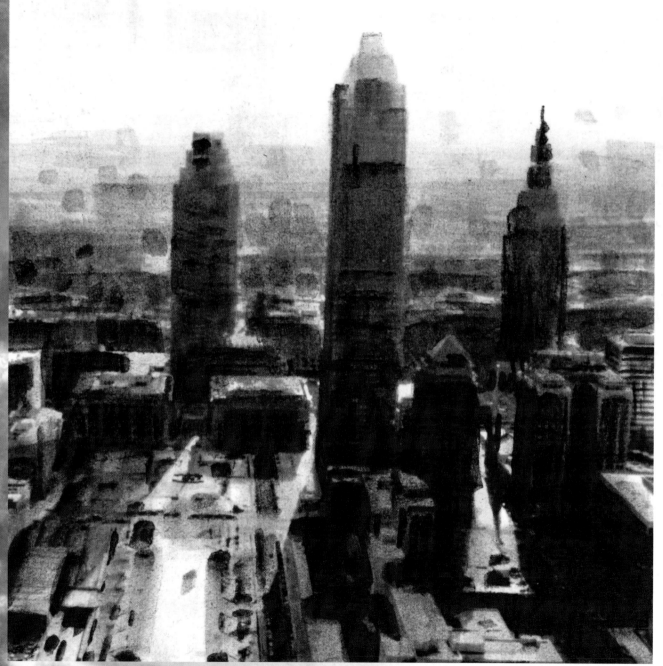

Left: Cleveland's tallest are, left to right, the BP America Building (1985), Key Tower (1991), and the Terminal Tower (1930).

Opposite, clockwise from top right:
The great window in the façade of the West Side Market lights the main hall, the domain of butchers, bakers, and fishmongers.

Display case, East Side Market. The smaller counterpart of the West Side Market, located at East 105th and St. Clair, was conceived and built in response to the loss of the old Central Market downtown.

Garden under glass, Cleveland Botanical Garden.

Rooftops, East 117th and Euclid.

Lindsey Alberding

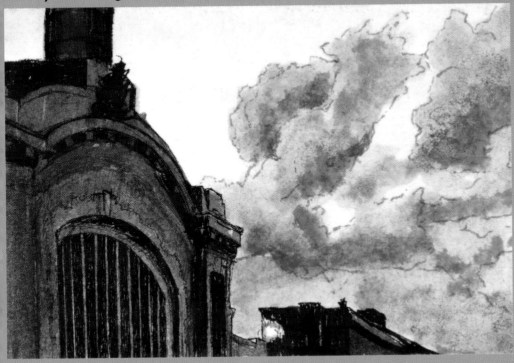

Cecelia Phillips

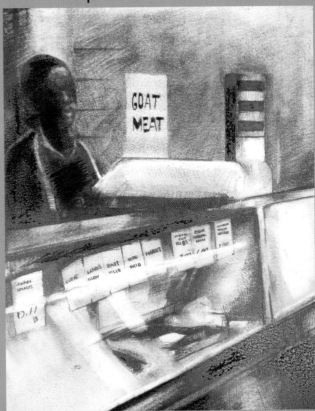

Mary Savage

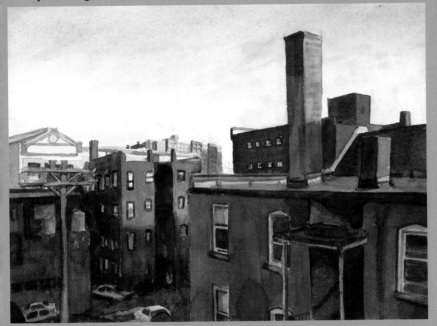

Albert Beltz

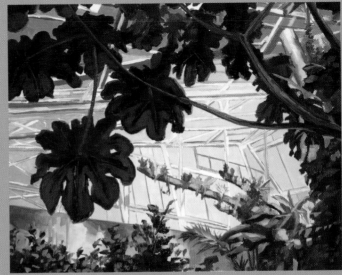

115

Mandy Stehouwer

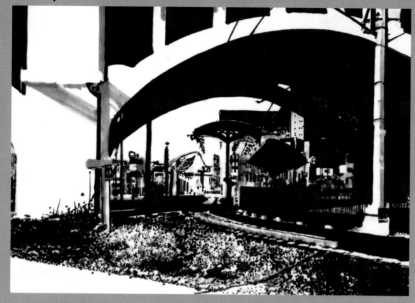

Wesley Burt

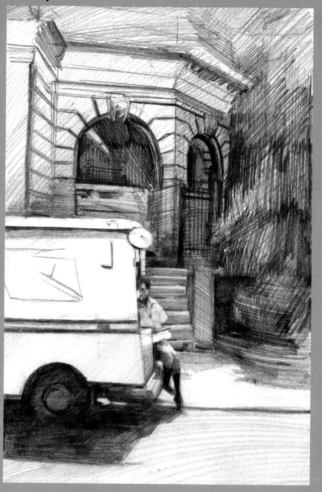

Christi Birchfield

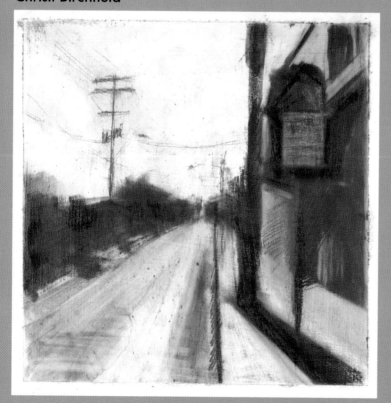

Clockwise from bottom left:
On Fleet Avenue, Slavic Village.

The RTA Waterfront Line, viewed
through an arch of the Detroit-
Superior High-Level Bridge.

Delivery, Park Lane Villa.

Opposite:
A shop on Lorain Avenue's
"Antiques Row."

Lindsey Alberding

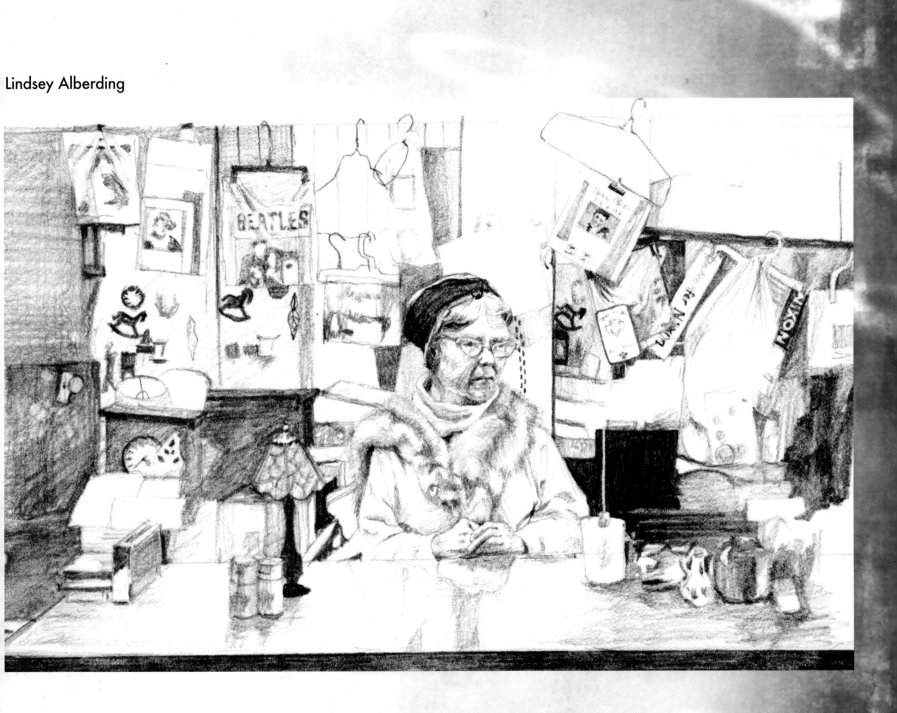

Nina Barcellona

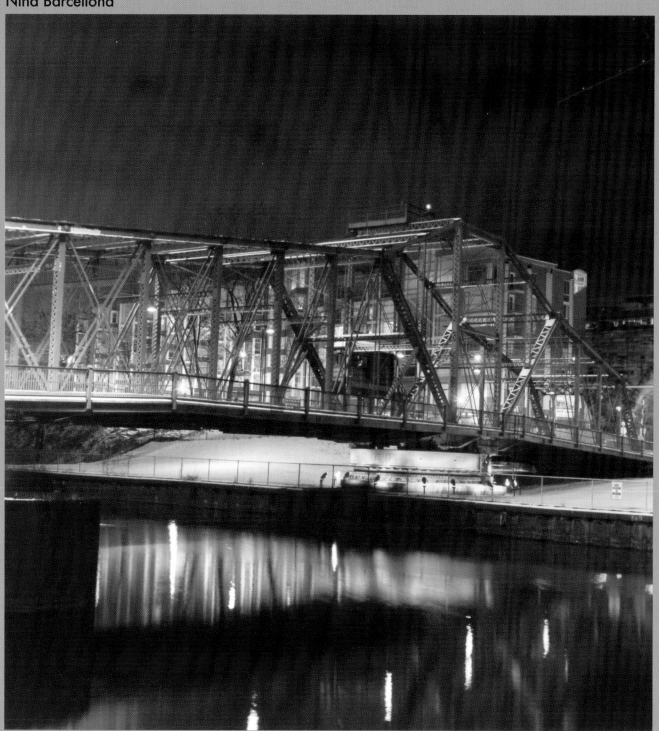

Left: The red-painted steelwork of the Center Street Bridge glows with the special lighting installed as part of the city's bicentennial celebration in 1996.

Opposite, left: Scene in Rockefeller Park, land for which was deeded to the city by John D. and Laura Spelman Rockefeller in 1897.

Opposite, right: Looking west from Euclid Avenue and East 115th Street.

Abby Feldman

Mary Savage

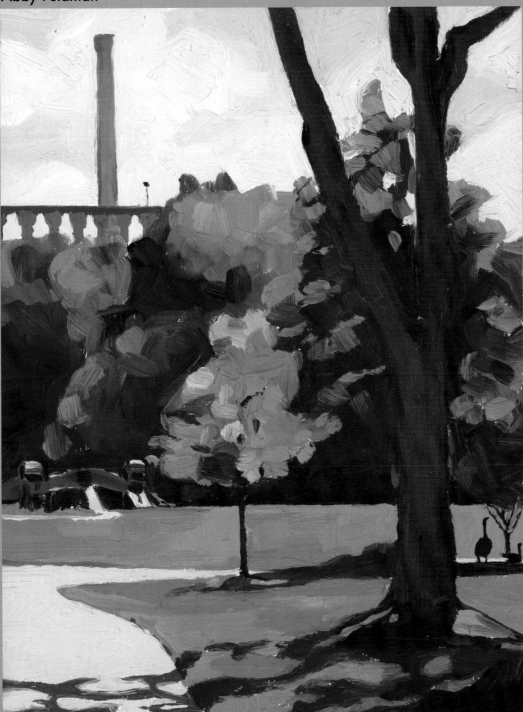

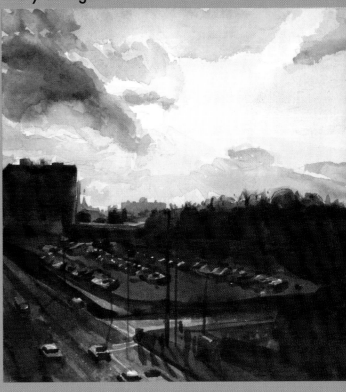

Wesley Burt

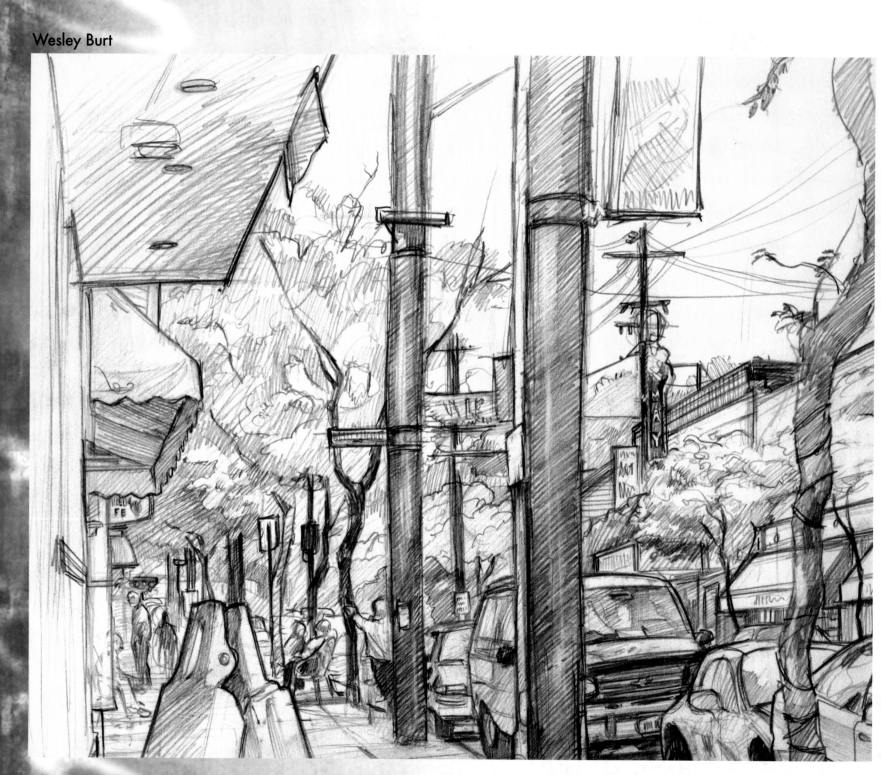

Sarah Laing

Andrew Zimbelman

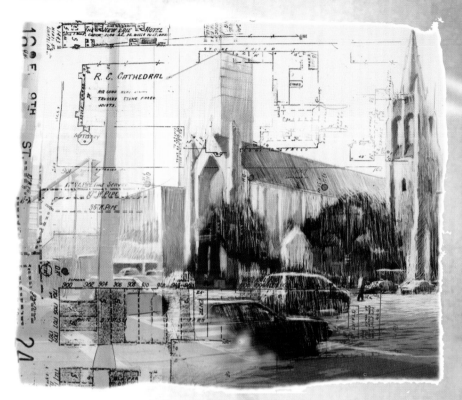

Ben Dewey

Opposite: The pleasant congestion of
Mayfield Road in Little Italy.

Clockwise from bottom left:
Old Brooklyn portrait: Brian J. Cummins,
former executive director of the Old Brooklyn
Community Development Corporation.

Relic, Otis Steel Company Riverside works

St. John's Roman Catholic Cathedral, East
Ninth Street and Superior, is the seat of the
Diocese of Cleveland, established in 1847.

Rachel Nottingham

Paul Koneazny

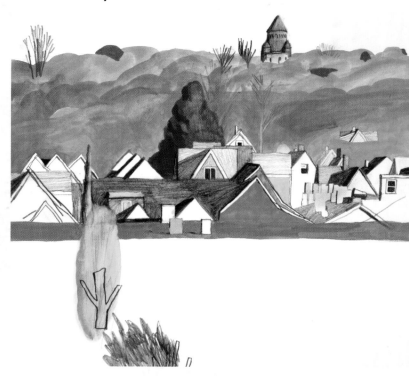

Peter Reichardt

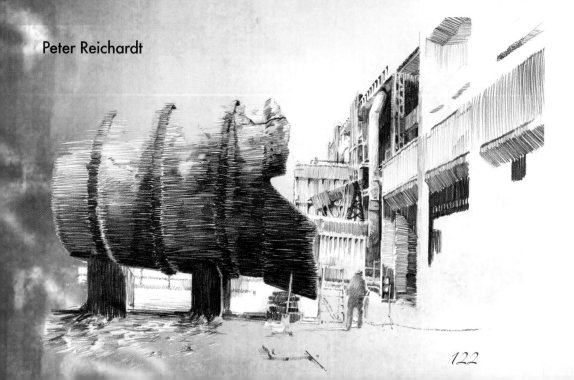

Clockwise from bottom left:
Relining a crucible, International Steel Group (now Mittal Steel).

Westbound on Memorial Shoreway (I-90).

The Garfield Monument rises above the trees in Lake View Cemetery, keeping a watchful eye on Little Italy. Immigrants from Italy's Abruzzi region settled the neighborhood, many of whose artisans carved the cemetery's stone monuments.

Rachel Nottingham

Peter Reichart

Cecelia Phillips

Clockwise from bottom left:
East Side portrait (untitled).

Like snowflakes, no two Lake Erie
sunsets are the same.

Steel mill scene.

123

Ben Dewey

Wesley Burt

Nina Barcellona

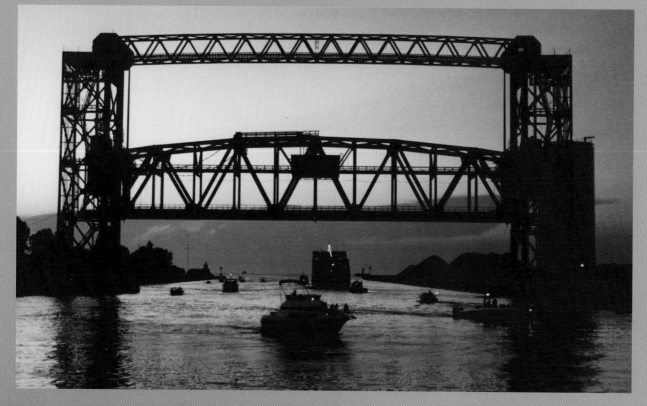

Clockwise from top left:
Old Brooklyn portraits: Don
Workman and Kenneth Johnson.

RTA Station, Tower City Center.

Dusk descends on the mouth of
the Cuyahoga.

Paul Koneazny

Wesley Burt

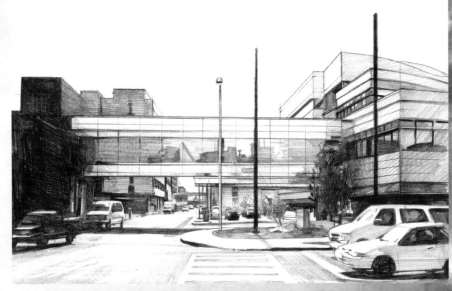

Christi Birchfield

Clockwise from top left:
Near the Agora, Euclid Avenue.

Pedestrian bridges and tunnels link a vast
network on the sprawling campus of the
Cleveland Clinic, the city's largest private
employer.

On Broadway in Slavic Village.

Mandy Stehouwer

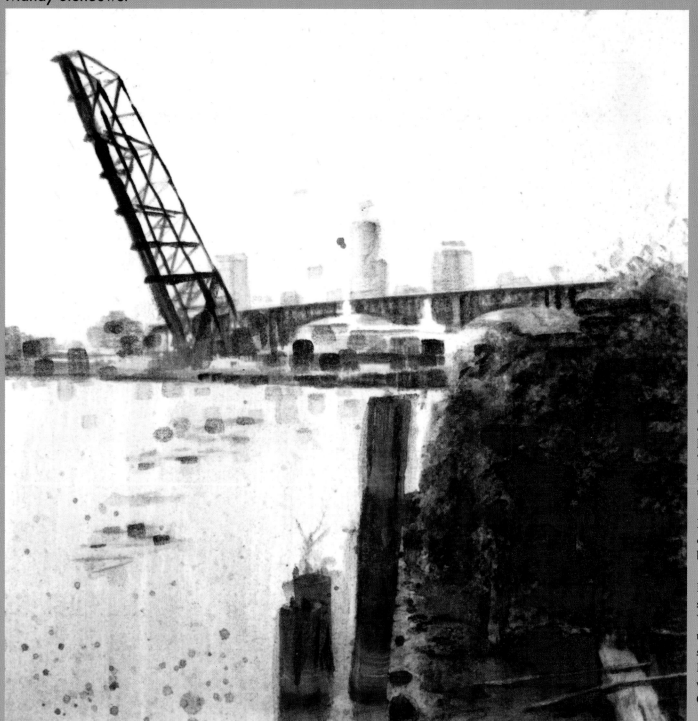

"There are the greatest lot of bridges here you ever saw," a visitor to Cleveland scrawled on a postcard in 1905. Knitting east and west sides together across the sinuous Cuyahoga Valley required the construction of numerous highway and railway bridges. To accommodate river traffic, many were of the moveable type.

Left: Looking toward downtown from the west bank of the Cuyahoga River.

Right: The vertical-lift span of the Norfolk & Western Viaduct frames the downtown skyline, sandwiched in between is the Lorain-Carnegie Bridge. The view is from West 14th and Crown.

Lindsey Alberding

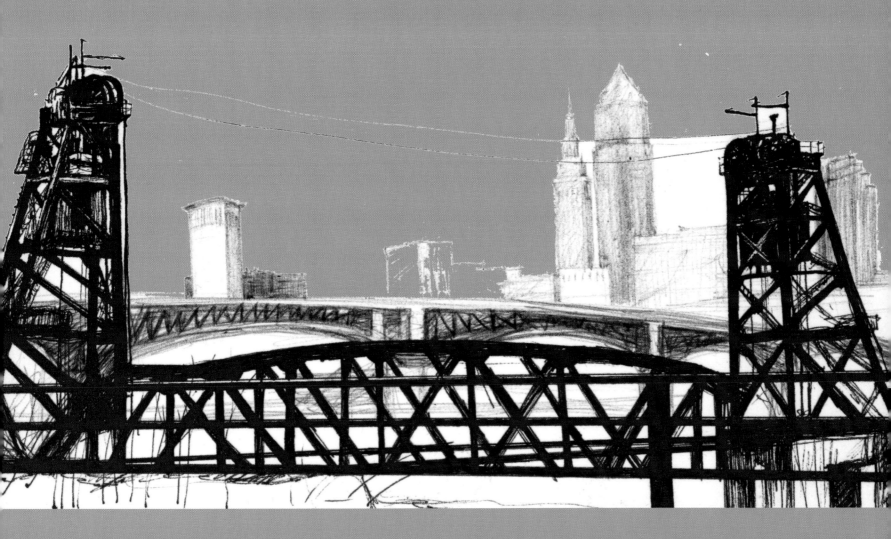

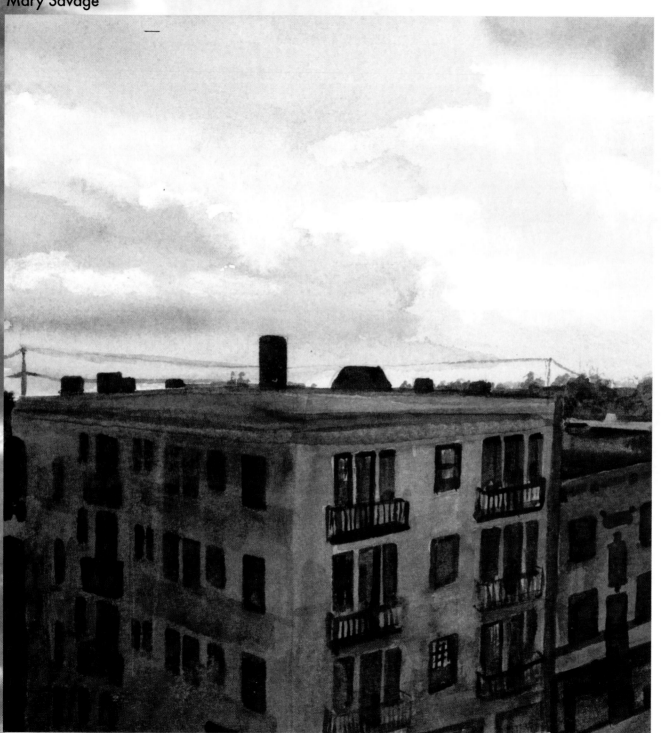

Left: The Monmouth, Euclid Avenue. As the city's population boomed in the early 1900s, developers erected hundreds of brick flats and terrace apartments. The lintel over the front door often bore an exotic and, now, inscrutable name.

Right: In his autobiography, *Boot Straps* (1943), Tom M. Girdler, the irascible chairman of Republic Steel, wrote, "The Cuyahoga River Valley, deeply etched across the industrial face of Cleveland, can be wonderfully beautiful in patterns of fire and darkness on nights when men are making steel."

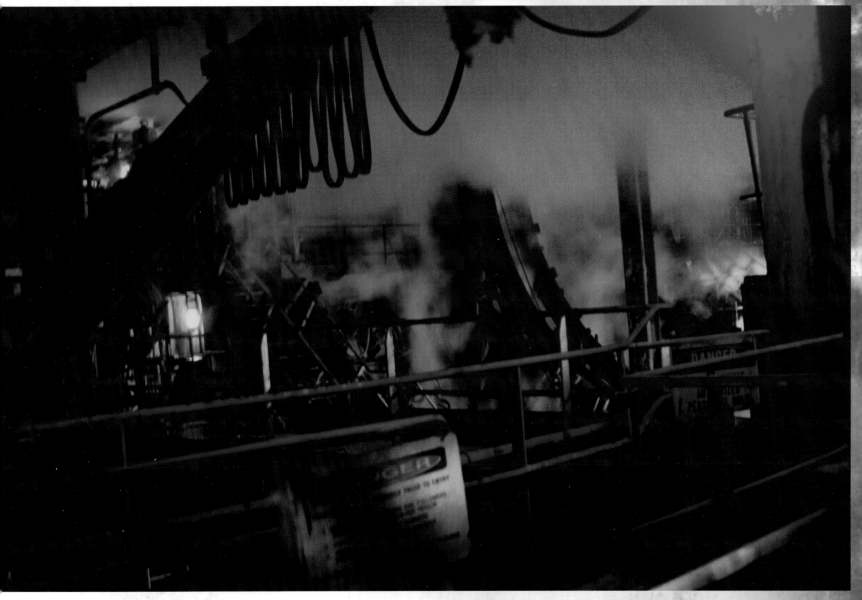

Cecelia Phillips

Mary Savage

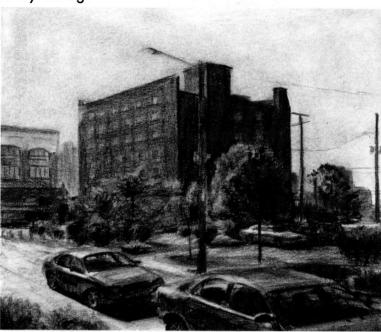

Paul Koneazny

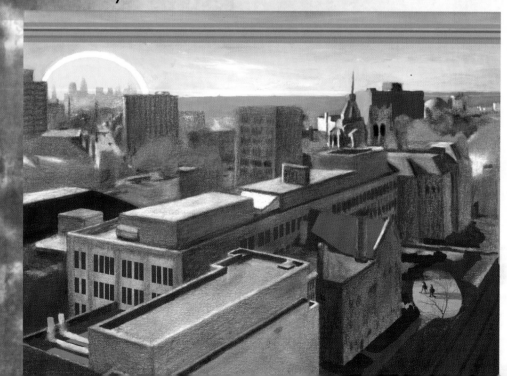

Clockwise from bottom left:
The view from University
Hospitals, looking northwest.

East 105th Street, Glenville.

East 116th Street and Euclid
Avenue.

Christi Birchfield

Clockwise from top:
Buyers and sellers engage in lively exchanges in the fruit and vegetable arcade at the West Side Market.

Literary and West Seventh, Tremont, where many street names—besides Literary, they include College, University, and Professor—recall the short-lived Cleveland University. Founded in 1850, it was dissolved after only a few years.

The view from the bridge is of a fog-draped downtown.

Mandy Stehouwer

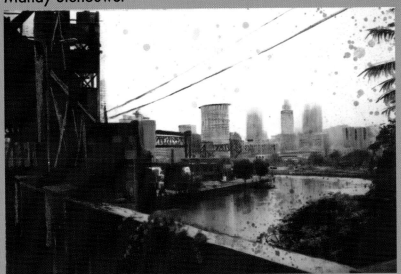

Lindsey Alberding

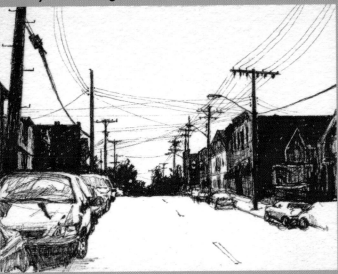

Lindsey Alberding

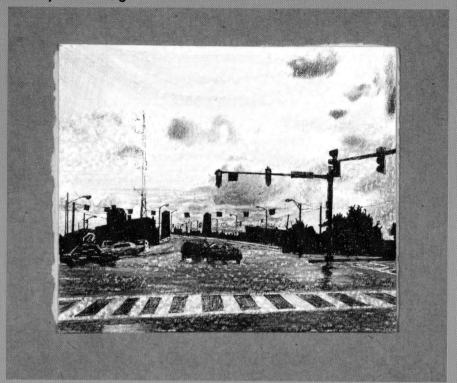

Mary Savage

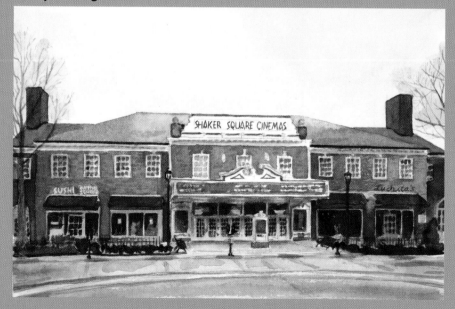

Mary Savage

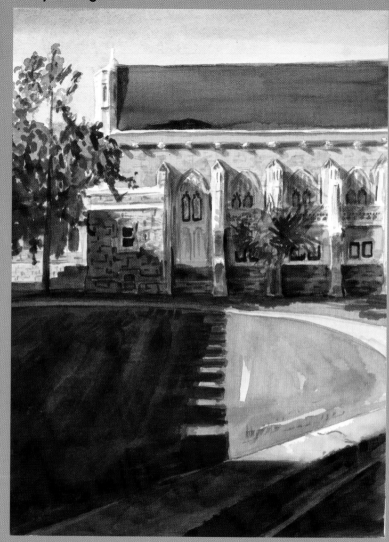

132

Mary Savage

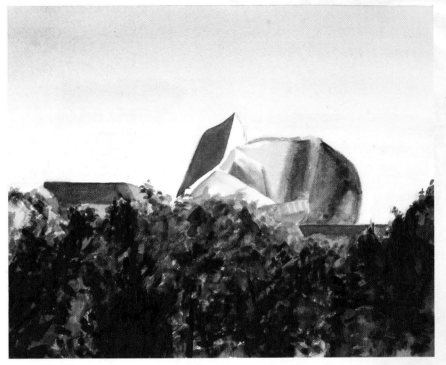

Lindsey Alberding

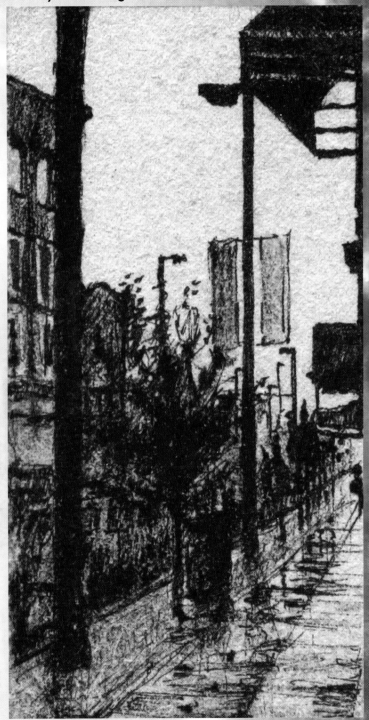

Left, clockwise from bottom:
The Colony Theatre (now Shaker Square Cinemas) opened on Shaker Square in 1937. Behind its staid Georgian Revival façade was a stunning streamlined interior designed by the Chicago and New York theater architect John Eberson.

The view west from Carnegie Avenue at Ontario Street.

Florence Harkness Memorial Chapel (1902), on Bellflower Road, is the work of Cleveland architect Charles Schweinfurth.

Above: The "exploding" crown of the Peter B. Lewis Building seems to float above the treetops on the Case campus.

Right: West 25th Street near the West Side Market.

Mary Savage

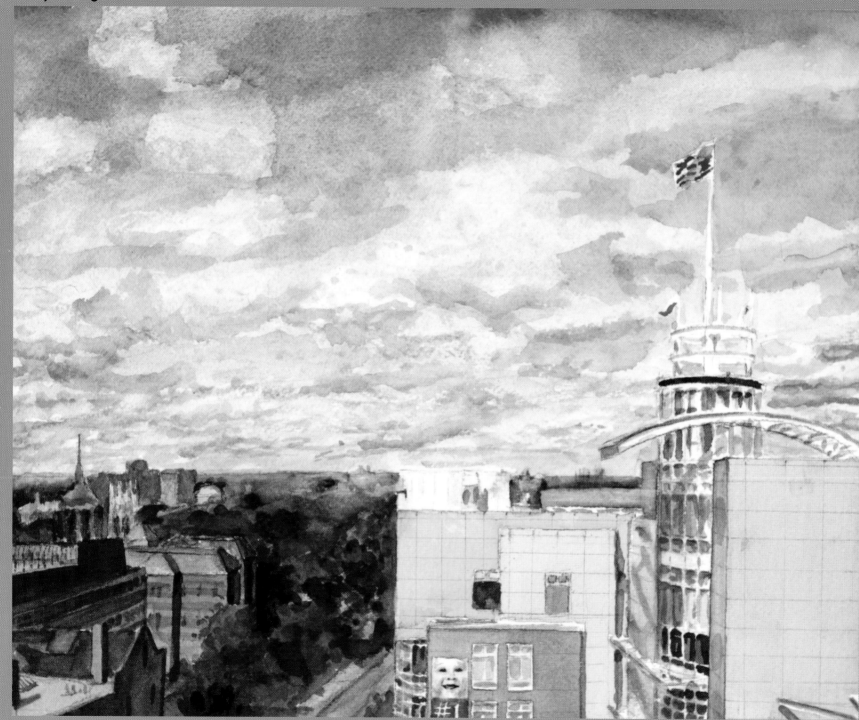

Cecelia Phillips

Wesley Burt

Left: Rainbow Babies and Childrens Hospital, part of University Hospitals of Cleveland, traces its roots to the establishment of the Infants Clinic, at the Central Friendly Inn, in 1906.

Above: East Side portrait (untitled).

Right: From the tower of the magnificent Church of the Covenant (1911), the music of the forty-seven-bell carillon suffuses the Case campus.

Mary Savage

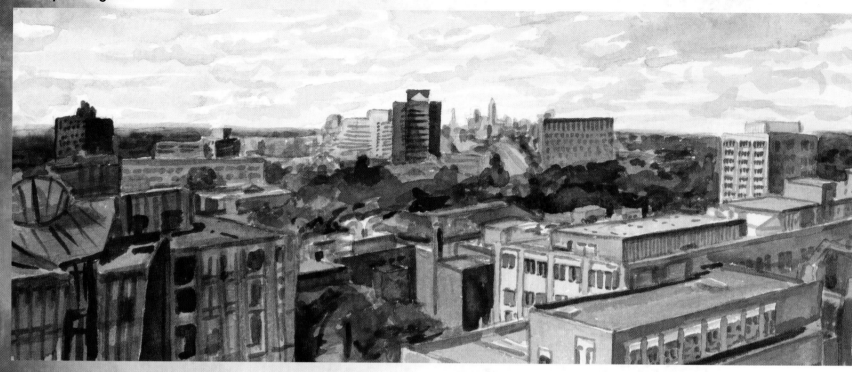

Cecelia Phillips

Clockwise from bottom left:
East Side portrait (untitled).

Looking toward downtown from
Adelbert Road.

Right: A glimpse of Florence
Harkness Memorial Chapel, on
the Case campus.

Mary Savage

Andrew Zimbelman

Wesley Burt

Christi Birchfield

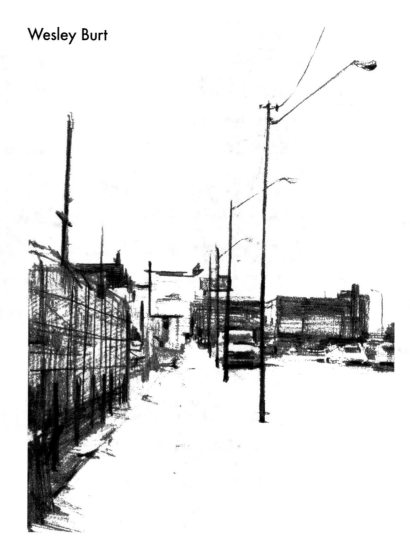

Clockwise from bottom left:
On Broadway in Slavic Village.

Skylight Court, Tower City Center. Following redevelopment of the former Cleveland Union Terminal into a shopping mall in the late 1980s, downtown retail activity shifted away from Euclid Avenue, the city's traditional shopping street, leaving numerous vacant storefronts.

On Euclid Avenue, uptown.

Paul Koneazny

Clockwise from right:
Bus stop, Superior Avenue.

Detroit-Superior High-Level
Bridge, winter.

At International Steel Group (now
Mittal Steel).

Nina Barcellona

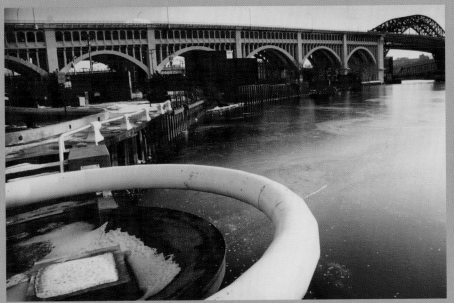

Sarah Laing

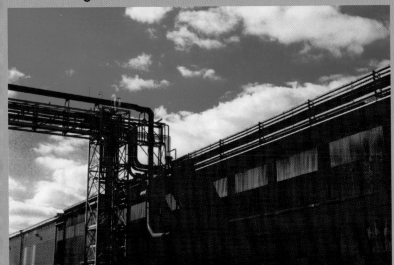

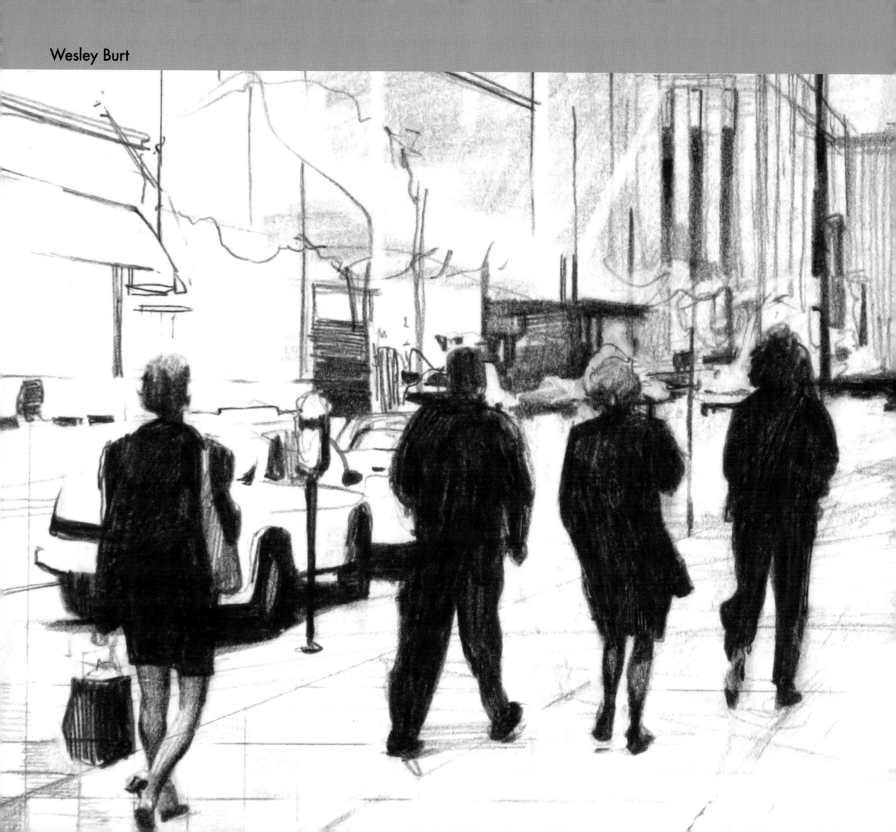

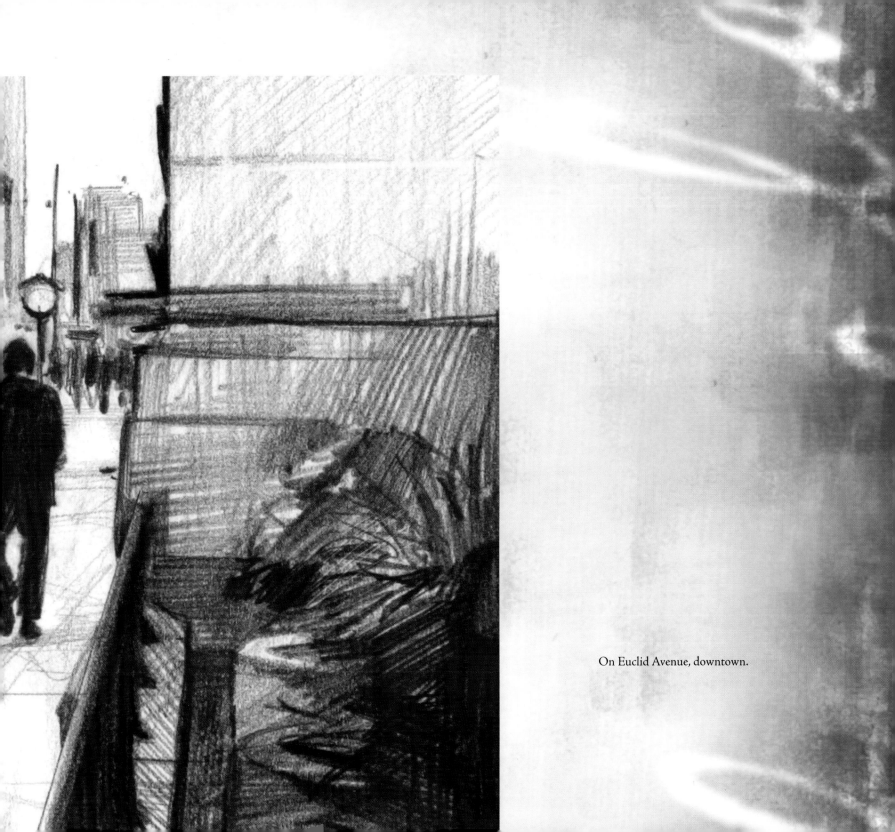

On Euclid Avenue, downtown.

Cleveland Sponsors

Sunset Memorial Park

Choosing a place for a loved one's interment is one of the most important—and most difficult—tasks we face. Sunset Memorial Park makes every effort to ease the strain and heartache associated with grief and bereavement in our lives. Committed to the belief that was the basis of their founding, Sunset continues to provide the best facilities with caring and compassionate service in a natural setting that offers dignity and comfort, continuing to be a timeless tradition for families of all faiths.

Westside Automotive

Westside Automotive Group, progressive and upscale in every respect, is steadily realizing its vision to be the leader in sales and service of Volvo, Jaguar, and Land Rover vehicles. With a commitment to "Price, Product and Service Excellence," Westside is an impressive, contemporary dealership facility that is equipped with a wealth of state-of-the-art technology. The largest minority-owned automobile business in the country, Westside Automotive Group offers unparalleled customer service, with the objective of exceeding expectations and creating customer loyalty through enduring relationships.

Cuyahoga Valley Scenic Railroad

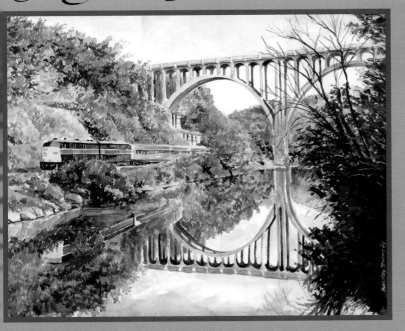

Cuyahoga Valley Scenic Railroad (CVSR) is one of the longest and most scenic tourist excursion railways in the country. CVSR today plays an important role in providing tourists with not only convenient transportation, but with destinations that are attractive to a wide variety of patrons. And, some excursions are an end to themselves, with a host of specially planned activities, creating memories for large groups of people who share common interests. CVSR is one of the most distinctive and successful passenger excursion railroads in the United States, providing a unique transportation experience to and through Cuyahoga Valley National Park and the Ohio & Erie Canalway.

Cleveland State University

Cleveland State University, strategically located in downtown Cleveland, is a comprehensive co-educational university of more than 16,000 students, offering degrees in 117 undergraduate and graduate programs. Begun to provide state-assisted, comprehensive programs of higher education for citizens of Northeast Ohio, the University provides quality, diversity, and flexibility in programs and courses, appealing to the widest possible range of students. Looking to the future, CSU has embarked on an ambitious expansion plan, striving to become an even greater student-focused center of scholarly excellence—a world-class university in a world-class city.

Cleveland Neighborhood Development Coalition

The Cleveland Neighborhood Development Coalition (CNDC) has been addressing the problems of economic, physical, and social distress in communities throughout greater Cleveland since 1982. The vision of a passionate and committed group of community leaders has extended beyond housing, encompassing jobs, social services, and most importantly, the development of community leadership and the empowerment of residents to take charge of their neighborhoods. Under the CNDC umbrella, a coalition of interested groups has come together to sustain the phenomenal change that is happening in the neighborhoods. Cleveland is fortunate to have these visionaries, providing the know-how and the grassroots organizing that have resulted in the creation of jobs, housing, and healthier neighborhoods.

Trolley Tours of Cleveland

When Lolly the Trolley appeared on the Cleveland scene in 1985, no one expressed much faith in the venture; even her trolley supplier thought he would have to buy back the vehicle within two years. What a difference twenty years makes! In 2205, Trolley Tours of Cleveland celebrated its twentieth anniversary with nine trolleys and one executive coach in its fleet, having served well over 1.5 million people. Lolly and her staff provide a vital, vibrant, and friendly image of Cleveland to both citizens and visitors in an atmosphere of safety, courtesy, and fun. Great memories are in store for those who enjoy the personal service of this outstanding company—it's a great ride.

The Lu-Jean Feng Clinic

Dr. Lu-Jean Feng is an internationally renowned Microvascular Plastic and Reconstructive Surgeon, specializing in cosmetic surgery of the face and breast. After a brilliant career in several prestigious hospitals, Dr. Feng decided to develop her own surgery center and enjoys the secluded location that provides maximum privacy for her patients. Her facility is like no other—tranquility reigns supreme, comfort and privacy are paramount, and a patient's every need is anticipated. Her business partner, Linda L. Haas, says of Dr. Feng, "...she is brilliant and is truly an artist, visionary, and surgeon all in one."

Travel Centers of America

TravelCenters of America is the largest full-service travel center network in the United States, serving professional drivers and motorists alike. Its passion is to make TA the highway traveler's choice. What began as "mom-and-pop" gas pump-and-diners in the '30s and '40s has evolved, through mergers and acquisitions, into a company with $2.7 billion in revenue in 2005, and with 160 locations to serve the traveling public. The company exists to meet the needs of all travelers, but drivers—those whose trucks bring a variety of goods to every American city every day—are the heart and soul of the business. This award-winning organization never sits on its laurels; it is always looking for new ways to serve the public, whether adding new brands to their variety of food offerings, or operating efficient shops to keep drivers safe on the road.

Cleveland Public Power

In business since 1906, Cleveland Public Power is the largest municipal power company in the State of Ohio, and the 35th largest in the nation. Even so, it operates in only one city, and that is fortunate for the citizens of Cleveland. A division of the city's Department of Public Utilities, Cleveland Public Power has only the best interests of this city as their central concern. Their well-qualified work force works hard to address the customers' needs in a timely fashion; complete customer service is the watchword. One of the most modern power systems in the country, Cleveland Public Power is committed to improving the quality of life for all citizens , and they prove it every day with splendid service.

Cuyahoga Community College

Since 1963, Cuyahoga Community College (Tri-C) has been serving the needs of approximately 55,000 students each year. Designed from the beginning to meet the needs of Cuyahoga County residents, the College offers degree programs that address local business and industry demands. As the College continues to build relationships with business, industry, and health care providers, it is enhancing job opportunities for its graduates, offering multiple ways of learning and boasting leading-edge technology, support systems, and flexible scheduling that help students achieve their goals. Obviously, Tri-C—the oldest, largest community college in Ohio—is preparing students of all ages for the lives they envision for themselves.

Cuyahoga County Board of Mental Retardation and Developmental Disabilities

Since the Ohio General Assembly established boards of mental retardation in Ohio counties in 1967, much has happened to improve the lives of citizens in need of special services. For instance, the term 'and developmental disabilities' has been added to its name, broadening the scope of those eligible for services. And the services are greatly expanded since those early years. From early childhood centers and community homes to special therapies and psychological services, the work of the Cuyahoga County Board of MR/DD encourages individuals with MR/DD to live, learn, work, and play. The cornerstone of its philosophy is self-determination and person-centered planning, transferring the power of decision-making into the hands of those directly affected.

The Cleveland Clinic

Founded in 1921 by four prominent Cleveland physicians, a not-for-profit group practice has grown into one of American's largest academic medical centers—The Cleveland Clinic. Specialty medicine is a hallmark of The Cleveland Clinic: the Heart Center, for instance, is one of the largest and busiest in the world. Other major specialties include cancer, ophthalmology, psychiatry, pulmonary, rehabilitation, gynecology, rheumatology, orthopaedics, otolaryngology, geriatrics, endocrinology, nephrology, and neurology and neurosurgery. As Cleveland's largest employer and a major economic presence, The Cleveland Clinic is committed to community enhancement and development, and is proud of its contribution to the continuing health and vitality of Northeast Ohio.

The MetroHealth System

The MetroHealth Sysem has been serving the medical needs of the Greater Cleveland community for more than 168 years, and today is one of the largest, most comprehensive health care providers in Northeast Ohio. Nationally recognized for its advanced techniques in treating complex problems, MetroHealth is the region's leader in critical care and only Level 1 Trauma Center for adults and children. And, with the creation of new community health centers and expansion of services in underserved areas, MetroHealth is redefining excellence in community and public health. MetroHealth never falters from its mission: to provide the highest quality health care—from pediatrics to geriatrics, from well-care to critical care—determined to become a national model in defining best practices in public health.

LifeBanc

LifeBanc is the nonprofit organ and tissue recovery agency serving Northeast Ohio, linking organ and tissue donors and those whose lives hang in the fragile balance, waiting for a transplant. As one of the original seven independent organ procurement organizations in the country, LifeBanc strives to maintain the highest standards of care and compassion while consistently delivering a message of life. Its history is comprised entirely of stories—stories of lives lost and lives saved, stories of ordinary people who gave a most extraordinary gift and those whose lives were forever changed by receiving those gifts. Everyone has the opportunity to become a part of the story by becoming an organ and tissue donor—the ultimate opportunity to share one's life with others. And LifeBanc is there to help you make that extraordinary choice.

Marous Brothers Construction

Marous Brothers Construction, a well-established first generation company, had its beginnings in small scale home remodeling. Now a multi-million dollar enterprise that provides its vast clientele expertise in both development and a myriad of contracting services, Marous is still led by brothers Chip, Scott, and Ken Marous. The brothers' passion for superb construction quality and design, along with their inimitable experience in seemingly every type of construction, has made the company one of the most sought after in the industry. Winners of numerous industry awards, the company is continually reinvesting in the community, preserving and beautifying the area. "Cleveland is a place we love to call home," says Chip. "We enjoy the diversity the city has to offer ... There's something for everyone." Marous Brothers is here to stay.

The Shamrock Companies

The Shamrock Companies, Inc., is a full-service marketing, communications, and project management company. Founded in 1978 by Neil Bennett, and named after the shamrocks that his grandmother grew during his childhood, the company now serves the U.S. market in sixteen cities. Over 6,000 of its clients recognize Cleveland as the home of The Shamrock Companies and share its sense of commitment to local enterprise. With expertise ranging from marketing and creative services to information technology, The Shamrock Companies capabilities include advertising, print, data management and IT services, broadcast media, premiums, medical solutions, and complete fulfillment services. One of the fastest growing companies in Northeast Ohio over the past five years, The Shamrock Companies has received numerous awards for business excellence and for community involvement, working to make Cleveland a great place to live, work, and visit in the years ahead.

Calfee, Halter and Groswold LLP

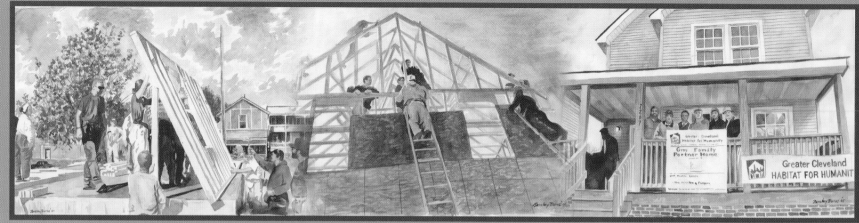

Calfee Habitat House 2003 - Built on a Firm Foundation

The law firm of Calfee, Halter & Groswold LLP has spent more than 100 years helping others achieve their goals, both organizational and personal. With over 200 professionals, Calfee's collective experience encompasses the entire spectrum of law for its clients—from mergers and acquisitions and litigation, to international and intellectual property, to lobbying and government relations. The insight gained from years of providing practical and client-directed counsel has given the firm a sincere appreciation for how its clients do business. Calfee is a founding member and the exclusive Ohio member firm of Lex Mundi, an association of independent law firms offering access to international representation in 155 countries. Whether in the boardroom, courtroom, or community, Calfee is proud of its history of and continuing commitment to helping others achieve their goals and aspirations.

Investment Planning Group, Inc.

Since 1964, when August DiVito opened the doors of Investment Planning Group, the business has provided its clients with "custom solutions for your financial needs." In 2000, Chris Divito succeeded his father as the firm's owner and president, bringing a decade of broad experience into the growing business. Chris, who has spoken extensively nationwide addressing groups in the financial industry, says the company's first priority is to assist clients in creating the wealth necessary to realize their personal and business financial goals. Always acting in their clients' best interest, Investment Planning Group has built a lasting foundation for success within the community. This commitment to client service has become a catalyst for the continued growth of Investment Planning Group, Inc., a company with a noble past and a promising future.

Cuyahoga Metropolitan Housing Authority

Early in the 1930s, Cleveland Councilman Ernest Bohn spearheaded the effort to establish public housing as a replacement for the tumbled down shanties where low-income families then lived. He was ahead of his time: in 1933, the State of Ohio chartered the Cuyahoga Metropolitan Housing Authority (CMHA) as the first public housing authority in the country. Many changes have taken place in public housing since that time, and the CMHA has been on the leading edge of much of that change. The success of CMHA is neither accident or luck, but the result of the commitment of a dedicated staff and leadership to providing, safe, quality, affordable housing for lower-income families and individuals. The years ahead promise more and better housing and a strong partner in revitalizing this community.

Cleveland Restoration Society

Founded in 1972, the Cleveland Restoration Society (CRS) is one of the country's leading historic preservation organizations and a Partner of the National Trust for Historic Preservation. Headquartered in the historic Sarah Benedict House, the CRS—through its Preservation Resource Center—makes historic preservation knowledge and assistance available to municipalities, organizations, and individuals throughout Cuyahoga County and its neighboring counties. CRS has gone from serving one city to now providing direct, substantive technical and financial assistance in fourteen municipalities through the Heritage Home Preservation Program. In today's quickly changing world, CRS recognizes that it takes all citizens working together to preserve and protect the precious remnants of the past. CRS takes seriously this collective responsibility to preserve the tangible reminders of our history for the benefit of present and future generations.

Hyatt Regency Cleveland

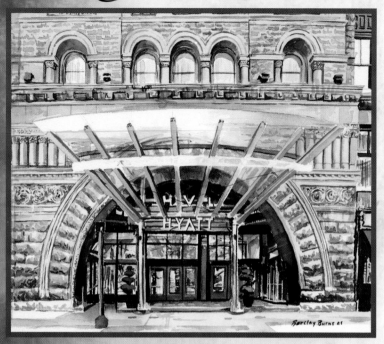

Cleveland's world-class hotel, Hyatt Regency Cleveland at The Arcade, combines the past and present with extraordinary results. Centrally located among the city's major businesses, restaurants, and local attractions, this luxury hotel offers beautiful accommodations, private meeting spaces, and exceptional service unequaled in the area. The Hyatt Regency Cleveland at the Arcade features 293 guest rooms, with high-speed wireless internet connections, a full-service restaurant and lounge, and over 7,000 square feet of meeting space in a lovely historic setting. Whether you're looking for the perfect weekend getaway spot, a meeting place with every necessary business amenity, or a grand and impressive setting for weddings, look no further: the Hyatt Regency Cleveland at the Arcade is the place for you.

Moen Incorporated

The premier name in plumbing products, Moen, Incorporated, has been revolutionizing the plumbing industry ever since the founder, Al Moen, introduced the single handle mixing faucet. Consumers, plumbing wholesalers, trade professionals, and retailers delight in and depend upon the company's comprehensive line of stylish and quality products. The company's strategic initiatives of growth, business improvement, and organizational excellence support its broad vision and overall operating philosophy that foster a culture where people are highly valued, and unparalleled customer service is paramount to success. The nearly 3,400 people employed by Moen are guided by the company's vision "To be the best consumer-driven global fashion plumbing and accessory products company." And they are. The company's dynamic workforce and innovative product and service offerings all promise a brilliant future for this company whose slogan is "Buy it for looks. Buy it for life."

Samsel Supply Company

When Frank J. Samsel purchased the rigging department of Frank Morrison & Son in 1958, they operated a business with about 1,500 square feet of space, an inventory of 300 items, and a staff of five. In the years since, the official name has become Samsel Supply Company, and today, occupies almost one hundred times its initial floor space, has nearly forty employees, and offers an impressive line of industrial, construction, and marine and lifting equipment supplies, tools, and specialty fabrication services. An affinity for growth and an ability to embrace change are the hallmarks of the company's success. Recognized for its longevity by both the Governor and the Council of the City of Cleveland for its long years in business, Samsel Supply has withstood the test of time, and continues to be in harmony with the evolving landscape.

University Circle and University Circle Incorporated

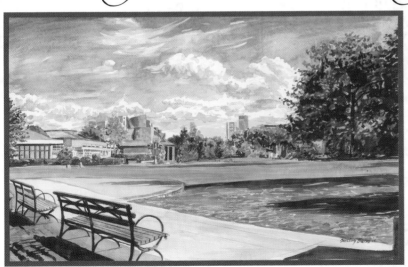

More than a century ago, a series of seemingly unrelated events began transforming Doan's Corners into University Circle. The donation of a large tract of land, now known as Wade Park, to the city of Cleveland assured a beautiful setting that would attract many institutions and visitors over the years. Today, more than fifty nonprofit cultural, arts, educational, medical, and religious institutions—including University Hospitals of Cleveland, The Cleveland Museum of Art, The Cleveland Orchestra, Cleveland Botanical Garden, and the Cleveland Museum of Natural History—make their home in this one square mile district. University Circle Incorporated is center stage in this ever-changing arena, which today is in the midst of a $1 billion development boom of new construction. UCI's mission is to achieve the community's shared vision for University Circle to become one of the world's premier urban districts: they are well on their way to a mission fulfilled.

Clear Channel Cleveland

In the rapidly changing world of communications, Cleveland's Clear Channel Radio is a dominant force in the market, serving the community through numerous formats. Through stations WTAM 1100AM, WMMS 100.7FM, WGAR 99.5FM, WMVX 106.5FM, WMJI, Majic 105.7, and KISS FM 96.5 (WAKS), Cleveland's Clear Channel presents an astonishing variety of programming, offering diverse voices and perspectives, distinctly different music choices, and unbiased, in-depth local news. Clear Channel's radio stations, though very diverse in format, collectively honor the mission to give back to the community, supporting key charities and initiatives significant to their respective audiences. Clear Channel Radio believes that Cleveland is a vibrant and diverse city worthy of celebration, and they have become a part of all the good things happening here. Tune in: there's something for everyone.

National City

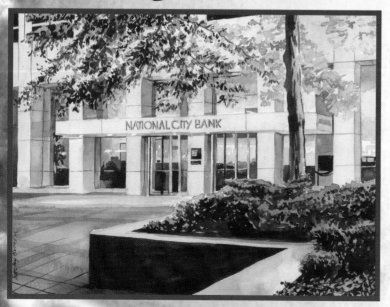

National City Bank had its beginnings in 1845, when Reuben Sheldon and Theodoric C. Severance organized the City Bank of Cleveland, the first institution chartered under the Ohio Bank Act of 1845. In 1865, after receiving its national charter, its name changed to National City and by the turn of the century, the bank was growing by leaps and bounds. National City withstood the Great Depression, and in the 1960s became one of the first banks to computerize savings deposit accounts. In 1984, National City acquired BancOhio Corporation, creating the state's largest bank holding company, and during that decade, began acquiring institutions in several surrounding states. Today, National City Corporation is one of the nation's largest financial holding companies, operating through an extensive banking network. National City has always had a long-standing commitment to its communities. Cleveland is its home; their stories will always be joined.

Cleveland Public Library

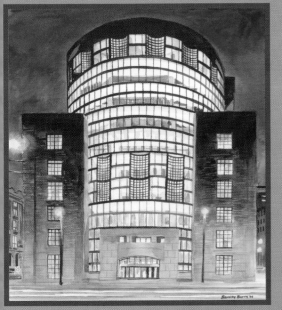

For over one hundred years, the Cleveland Public Library has been a beacon of educational development for Ohio's citizens. Since its beginning in 1869, the Library has taken pride in supplying library services and a wide range of cultural enrichment programs through unparalleled community access. The library system today covers seventy-seven square miles, with the historic Main Library and Louis Stokes Wing at the center. "This library understood the benefits to the reader of direct access to books," explains Andrew A. Venable, Jr., director of the Cleveland Public Library. "…our mission is to provide the access to books and worldwide information that people and organizations need in a timely, convenient, and equitable manner." A network of twenty-eight branches planned around the principle of neighborhood availability offers innovative services to the entire area. The Cleveland Public Library values the people it serves.

Miceli Dairy Products Company

Miceli Dairy Products Company began when a young man named John Miceli wanted to find a way to use the surplus milk from the Newbury dairy farm that belonged to his father, Anthony Miceli. They came up with a simple plan for using the surplus: they would make cheese! As producers of several varieties of cheeses, including the popular ricotta, the Miceli family has earned a place of prominence in the fresh Italian cheese market. Today, Miceli Dairy Products produces 125,000 pounds of ricotta per day; their speciality lines include asiago, bocconcini, and the pepperoni roll, and a variety of "lite" products. They continue to be family business, owned by family, operated by family. They remain committed to the legacy of John Miceli Sr, producing the best cheeses to be found anywhere for a market that loves them—like family.

WNWV The WAVE

If you've discovered Smooth Jazz 103 The WAVE, you know you're tuned in to locally owned and operated WNWV, a station that has developed a variety of music, events, and features that appeal to the discerning listener. Smooth Jazz has been at home in Northeast Ohio for the past seventeen years, building a loyal and faithful following of listeners who never change the dial. The WAVE events calendar offers popular choices for its audience—from Nights at the Improv, America's Premier Comedy Showcase, to joining the WAVE team at Pickwick & Frolic Restaurant & Club for an extravagant Sunday brunch. Their Thursday Breakfast Break has brought breakfast to over 100,000 companies as they visit companies large and small throughout the area. Tune in: they've been waiting for you.

CBIZ, Inc.

CBIZ, Inc., a Cleveland-based company employing 4,700 associates in over 140 offices in 34 states across the country, exists to help business owners do what they love doing. Administrative tasks such as taxes, payroll, benefits, and human resources needs are necessary components of all businesses, but they take an inordinate amount of time—and that's where CBIZ comes in. They assist clients with a wide range of professional services and solutions that help them better manage their finances, employees, and technology, all with a single focus: the client's success. A publicly-traded, thriving enterprise with annual revenues over $500 million, CBIZ provides a complete range of services to its clients, freeing them up to do what they went into business to do in the first place.

Greater Cleveland Regional Transit Authority

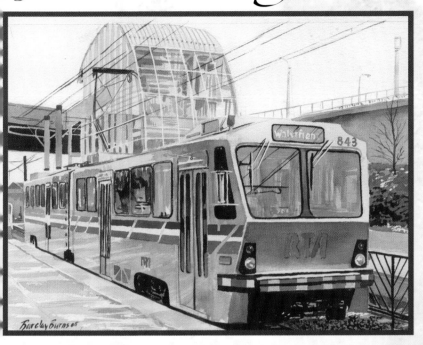

Formed in 1975 through the consolidation of several lines, GCRTA is the nation's thirteenth largest public transportation, with a service area of more than 458 square miles and 1.4 million people. Daily, the system operates more than 100 bus routes and four heavy-and light-rail transit lines, transporting 200,000 commuters to their destinations. The system uses the latest technology to improve every phase of the commuter's experience, including the use of Global Positioning Technology to pinpoint the exact location of every transit authority vehicle, right down to the street corner. GCRTA gains insights into its riders needs through its Citizens Advisory Board, and this has resulted in the development of a new transit waiting environment and many improvements to routes and schedules. Committed to moving people from place to place, GCRTA is also committed to moving the 59 municipalities it serves forward to a bright future.

University Hospitals Health System

Founded in 1866 as a hospital to serve the underserved, University Hospitals Health System today is a health system that includes seven wholly owned hospitals, four partner hospitals, and service at more than 150 locations in Northeast Ohio. The growth has been impressive, yet, over time, the essential mission has not changed: an abiding commitment to provide outstanding patient care; to educate the next generation of physicians; to conduct pioneering research; and above all, to serve the community. The hospital's history is filled with medical innovation, leading-edge research and teaching, and most importantly, a bedrock commitment to outstanding patient care and community service. Today, it is still the personal care its patients receive that continues to define and fulfill its promise of providing "Advanced Care, Advanced Caring."

Index